MW00613005

IMAGES
of America

MONMOUTH
COUNCIL
BOY SCOUTS

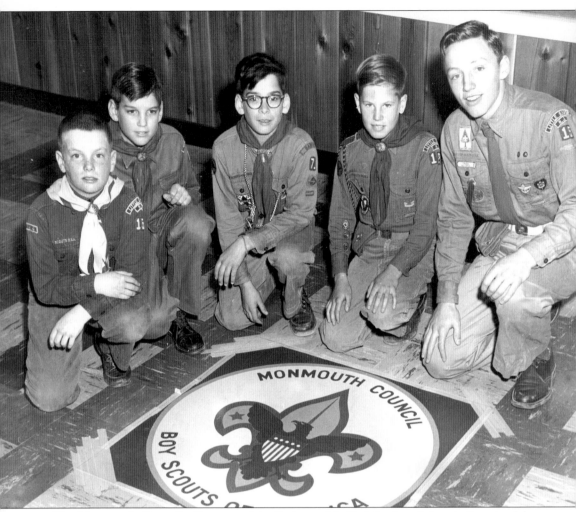

The Monmouth Council office was originally located in Red Bank and then in Farmingdale at Allaire Village, Asbury Park, Long Branch, and finally Oakhurst. The special tile shown here was inlaid in the floor of the newly constructed E. Donald Sterner Scout Headquarters, built in 1956 specifically as a Boy Scout council office. Helping to recognize the occasion are, from left to right, Robert Nordt (Pack 15, Little Silver), unidentified, unidentified (Troop 71, Oakhurst), David Winfield (Troop 127, Little Silver), and Richard Werner (Squadron 15, Little Silver). The tile is in the Scout executive's office. In 2002, the Oakhurst property was sold for $1.4 million as part of plans for the office to move to a larger building.

IMAGES
of America

MONMOUTH
COUNCIL
BOY SCOUTS

David Alan Wolverton

ARCADIA

Copyright © 2003 by David Alan Wolverton.
ISBN 0-7385-1171-4

First printed in 2003.

Published by Arcadia Publishing,
an imprint of Tempus Publishing Inc.
2A Cumberland Street
Charleston, SC 29401

Printed in Great Britain.

Library of Congress Catalog Card Number: 2002116862

For all general information, contact Arcadia Publishing:
Telephone 843-853-2070
Fax 843-853-0044
E-mail sales@arcadiapublishing.com

For customer service and orders:
Toll-free 1-888-313-2665

Visit us on the Internet at www.arcadiapublishing.com.

On the cover: Inside the Housman Memorial Lodge, the Scouts of Little Silver Troops 126 and 127 sit down to a hearty meal. Although the dining hall had just been built when this *c.* 1958 photograph was taken, there were already a few troop plaques on the walls, starting a tradition that continues to the present day.

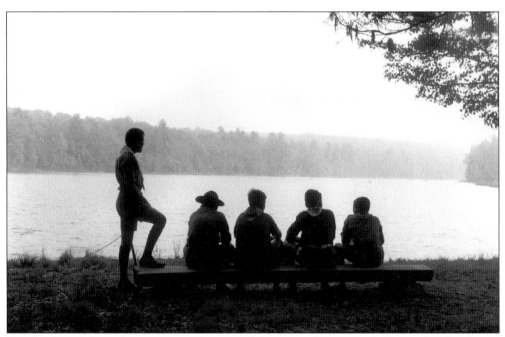

This book is dedicated to the many Scouts and Scouters of Monmouth Council with whom I have had the pleasure of camping, hiking, and Scouting.

CONTENTS

ACKNOWLEDGMENTS

When I was working on the Forestburg staff in 1978, I got to see Keith Bradbury's collection of Forestburg patches. He inspired me to start my own Forestburg collection, which eventually broadened to include all memorabilia of Monmouth Council 347. As I built my collection, I wanted to know more about the people and events behind the patches. This led me to research the history of the council and to write this book.

Many people contributed to this effort to document the council's history, including Mike Badal, J. Fred Billett, Ray Bossinger, Steve Buckley, Bill Burket, David Crow, George Cuhaj, Dave Dellett, Don Dellett, Nick DeMarco, Kevin Dorey, Walter Downing, Jay Dunbar, the Engeldrum family, Tom "Bear" and Kate "Momma Bear" Fraley, Rich Goldman, Bud Hassler, Randy Holden, John Horvath, Jim Kay, Rev. Dr. Lewis Kisenwether Jr., Mike Korda, Robert Lawrence Jr., Tony Liberto, Carl Mason, Wayne Mason, Rick Obermeyer, Wes Olson, Alice and Bill Quakenbush, Mitch Reis, Jodi Stark, Sandy Tallman, Matt Thornton, Ed Weickel, Marg and Frank Wolverton, Mike Wyman, David Malatzky and Bernie Sussman of the Ten Mile River Scout Museum, Scott Peters of Allaire Village Inc., the staff of Monmouth Council, the staff of the Red Bank Public Library, and the photograph contributors named in the captions.

The work of two photographers appears throughout this book. A.F. Werner of Little Silver shot many Scouting scenes around the county in the 1950s, including the council's camp promotion pictures of Forestburg c. 1957–1958 and the Exploring program. George Engeldrum of Lincroft followed in Werner's footsteps; from the late 1950s to the 1980s, he photographed everything from Order of the Arrow powwows to formal Forestburg staff pictures and troop events. He was also a model neighborhood commissioner. The Twin Lights District annually presents the George Engeldrum Award in his honor to the outstanding commissioner of the year.

If there is one person who deserves special recognition in a history of Monmouth Council, it is J. Fred Billett. Under his stewardship as Scout executive, the council grew dramatically in both size and status. He marshaled the resources to build the Oakhurst service center and purchase and develop both Quail Hill and Forestburg. Even when his professional responsibilities took him away from us, Fred kept his eye on the council; after retiring, he returned to serve the council as a volunteer. Without his contributions, the Monmouth Council seen through the images on these pages would have been far different.

INTRODUCTION

Monmouth Council is one of the few remaining "county councils" in the country—most have merged with their neighbors to form megacouncils. This has helped the Scouting program here retain a small-town quality. Yet, with as many as 10,000 youths involved in a given year, its impact on the lives of young people in Monmouth County has been significant. It is my hope that this book will help the current generation of Scouts and Scouters understand the grand tradition of Scouting of which they are a part.

Monmouth County Council 347 of the Boy Scouts of America has operated continuously since it was founded in 1917. Originally, the council served the entire county of Monmouth. The council also served the Jamesburg State Home for Boys in Middlesex County beginning in 1922. In 1927, the council's reach was extended to include Ocean County. By 1939, Scouting in the Ocean County area had matured enough that it could stand on its own, and Ocean County Council 341 was chartered. Allentown was transferred to George Washington Council (now Central Jersey Council), and it is now the only town in the county not served by Monmouth Council.

From the beginning, a cornerstone of the Scout program has been camping and the outdoors. Most councils own or operate one or more camp properties. Monmouth Council has operated a variety of different camps since its founding. These ranged from traditional summer camps to Explorer bases.

> Camp Monmouth (Camp Minnewaska), Shark River Hills, New Jersey, c. 1918–1921
> Camp Cowaw at Kanohwahke Scout Camps, Tuxedo, New York, c. 1918–1921
> Camp Burton, Adamston, New Jersey, 1924–1928
> Camp Burton-at-Allaire, Farmingdale, New Jersey, 1929–1940
> New Jersey Sea Scout base, Fort Hancock, Sandy Hook, New Jersey, 1933–1936
> Camp Mennen Harbor (Sea Scout base), Fair Haven, New Jersey, 1940s
> Camp Brisbane (Camp Housman), Farmingdale, New Jersey, 1946–1967
> Spermaceti Cove Sea Explorer Training Base, Sandy Hook, New Jersey, 1950s
> Hidden Hollow (primitive troop camping), Holmdel, New Jersey, early 1960s
> Poricy Pond (day use), Middletown, New Jersey, late 1960s
> Skelbo Lodge Explorer Base, Bracebridge, Ontario, Canada, early 1960s
> Forestburg Scout Reservation, Forestburgh, New York, 1956–present
> Quail Hill Scout Reservation, Manalapan, New Jersey, 1967–present

The original Boy Scout program was designed for boys ages 12 through 17. Once it was clear that the concept would succeed, additional variations were created. The Senior Scouting program, for those up to 21 years of age, first appeared in the council in the form of Sea Scout Ship 1, chartered in 1929 in Red Bank (Explorer posts, Air Scout squadrons, and Venture crews followed later). The Cub Scout program for younger boys was unofficially in use in the late

1920s, and the first official pack was chartered in 1931 in Long Branch. Order of the Arrow Lodge 71 operated during the 1930s but then became inactive until 1950, when Na Tsi Hi Lodge 71 was founded. In the 1980s, the Learning for Life program was introduced. Each of these programs added a new dimension to the Scout world, as well as a new opportunity to serve youths.

In this book, you will find images of both familiar and unfamiliar places. No matter what the uniform looked like, or which camp the Scouts were at, the basic idea of teaching citizenship, self-sufficiency, values, and respect for others through the Boy Scout program has not changed. So let us set out on the Scouting trail.

One

THE PIONEER YEARS

Scouts have been in Monmouth County since the beginning of the Scouting movement in America. Early troops were chartered in Atlantic Highlands (1911) and Allentown (1912), as well as Long Branch, Red Bank, and other communities. By the earliest available census, which was in 1913, the national office had registered 300 Scouts in Monmouth County. The number had grown to 892 Scouts registered in 43 troops by 1917.

As the Scouting movement prospered, local councils were organized across the country to provide trained local leaders and to handle administration. Sigmund Eisner brought Chief Scout Executive James E. West to Monmouth County to help organize the Monmouth County Council. It was chartered in August 1917 and was a "First Class" council, meaning that it had a paid professional. Merritt L. Oxenham was the first Scout executive. Oxenham had begun his association with Scouting as a Scoutmaster in Puerto Rico in 1910 and, among other accomplishments, had been a special field Scout commissioner in Brooklyn and Queens.

A campsite, called Camp Monmouth in one newspaper article, was located in the Shark River Hills area. It was being used for weekend trips in 1918. By 1921, under the name Camp Minnewaska, it was being used for summer camp programs under the direction of Scout Executive John Danton. It had dining facilities with a professional cook, and swimming and boating facilities.

Farther north in the Palisades Interstate Park (now Harriman State Park) in New York, a federation of several New York and New Jersey councils, including Monmouth County Council, operated a system of camps called the Kanohwahke Scout Camps. Each camp was designed to serve 100 boys and had its own dining hall and staff. At its zenith, there were about 30 of these camps at Kanohwahke Lakes. The camp chief was pioneer Harvey A. Gordon. Among his many accomplishments, he was "grand scribe" for the Grand Lodge of the Order of the Arrow in the 1920s, supervised construction of the Ten Mile River camps, and was the engineer for the 1937 National Jamboree. Monmouth County Council troops used this camp from c. 1918 to 1921.

The Housman family of Elberon donated Camp Burton, which was in Ocean County on the Metedeconk River between Bay Head and Laurelton. It operated from 1924 to 1928, until the council acquired a lease on the Allaire Village and opened Camp Burton-at-Allaire. The Camp Burton property was later sold to real-estate developers.

In the spring of 1927, the Ocean County area was added to the council and the word "County" was dropped from the Monmouth County Council name. In 1937, the council's name was changed to Monmouth-Ocean Council. Ocean County Council 341 was formed in 1939, and the council's name was changed yet again, back to Monmouth Council.

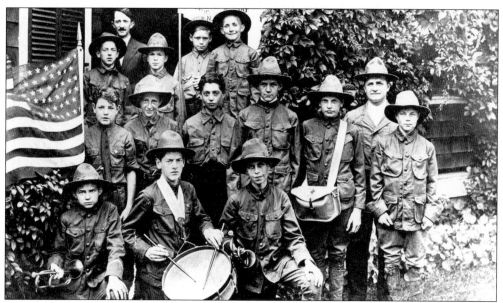

In the summer of 1911, the boys of Atlantic Highlands formed a troop that met at the home of Helen Brown. She recruited Rev. J.H. Schaeffer to be the Scoutmaster, and Troop 1 (now Troop 22) was chartered on December 1, 1911. Twenty-four Scouts in the troop served in World War I. Paul Brunig was killed in September 1918, but the other 23 returned home safely.

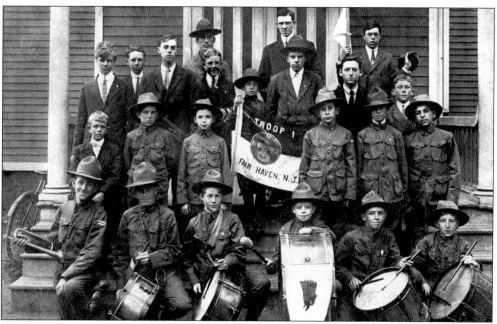

Fair Haven Troop 1 must have enjoyed marching in parades with all those drums. In this early-1900s photograph, the boy standing to the right of the troop flag is George Curchin. This was the forerunner of Troop 24.

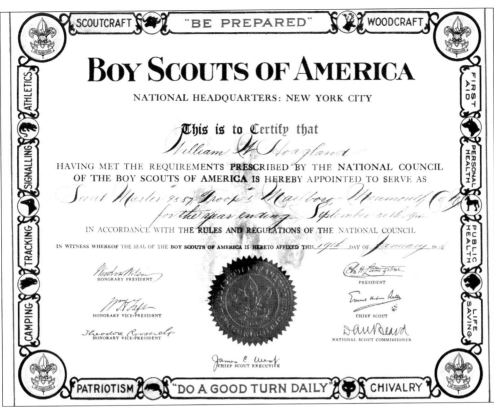

This certificate shows that William W. Hoagland was registered to serve as Scoutmaster of Troop 1 of Marlboro for 1914. Prior to 1917, all Monmouth County Scouts and leaders were registered through the national office in New York City because a local council in Monmouth County did not yet exist.

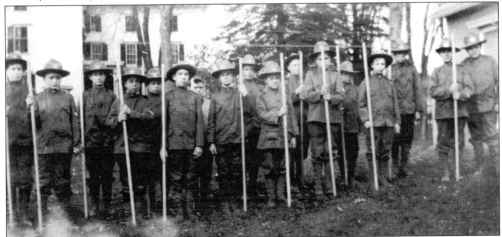

Lawrence Lodge at Quail Hill is named for Dr. Robert P. Lawrence, who was a Scout in this c. 1914 Rhode Island troop. Their hat badges indicate that this was a Rhode Island Boy Scouts (RIBS) troop. The RIBS was formed in 1911 and was one of several youth groups that competed with the Boy Scouts of America for members. The RIBS merged with the Boy Scouts of America in 1917.

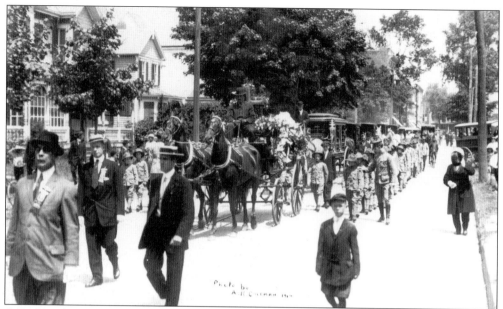

A Red Bank troop served as the escort in a funeral procession in 1914. In this photograph by noted Red Bank photographer Andrew R. Coleman, each boy is well uniformed for the ceremony in a coat, breeches, and leggings that were sewn only a few blocks away in the legendary Sigmund Eisner Company factory. (Photograph courtesy of Dorn's Photography Unlimited Historical Collection.)

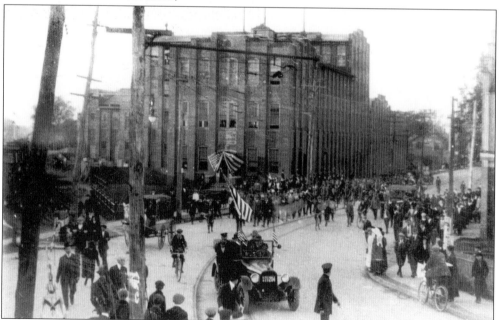

This photograph of the main Sigmund Eisner Company uniform factory on Bridge Avenue in Red Bank dates from 1916. Eisner had other factories, especially during the peak war years. All Boy Scouts of America uniforms were made in Eisner's factories from 1910 to 1933, although accessories such as hats and belts were probably subcontracted to other firms. (Photograph courtesy of Dorn's Photography Unlimited Historical Collection.)

Sigmund Eisner, the founder of the uniform company bearing his name, was born in Horazdovice, Bohemia, in 1859. He was penniless when he arrived in the United States in 1881. Eisner started his sewing business in 1888. He was extremely generous to his employees and supported many local charities. The pallbearers at his funeral in 1925 included Dan Beard, James West, and Colin Livingstone. (Photograph courtesy of Dorn's Photography Unlimited Historical Collection.)

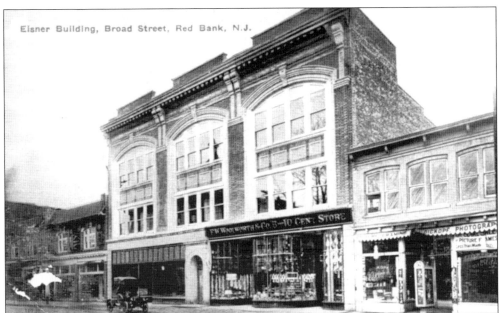

Eisner Building, Broad Street, Red Bank, N.J.

The first Monmouth County Council office was in the Eisner building on Broad Street in Red Bank in 1917. Monroe Eisner, one of Sigmund's sons, was a Monmouth County Council founder in 1917 and was a council officer for many years.

"This garment is purchased with the understanding that it is for the sole use of......................
..............................a duly enrolled member of........ Patrol of Troop No.........of............
.....................of the Boy Scouts of America. Any other use of it will violate the rules of the Boy Scouts of America and the contract of the merchant under which it is possible to sell the garment at its present low price. No one who believes in fair play will attempt to violate this agreement.

Any other boy than a Boy Scout who attempts to purchase or wear this uniform will be regarded by other boys and the officers of the Boy Scouts as an imposter."

BOY SCOUTS OF AMERICA
Hdqts. 200 Fifth Ave.
New York City

SIGMUND EISNER
Official National Outfitter
Red Bank, N. J.

The label sewn inside each Eisner uniform gave a stern warning that the purchaser must be a registered member of the Boy Scouts of America. At the same time the Boy Scouts of America was getting started, other boys' groups with similar names—such as the American Boy Scouts (Randolph Hearst's organization), the Rhode Island Boy Scouts, and the Lifesaving Scouts (the Salvation Army's organization)—were also recruiting members.

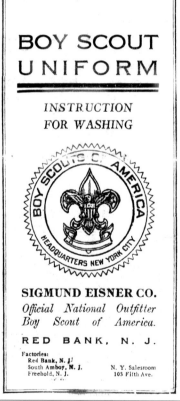

COPYRIGHTED 1910

WE also manufacture various styles and classes of uniforms for men and boys U. S. Army, National Guard and Private Military Institutions. Would be pleased to submit samples and prices on request.
SIGMUND EISNER CO.

BOY SCOUT UNIFORM

INSTRUCTION FOR WASHING

SIGMUND EISNER CO.
Official National Outfitter
Boy Scout of America.
RED BANK, N. J.

Factories:
Red Bank, N. J.
South Amboy, N. J.
Freehold, N. J.
N. Y. Salesroom
103 Fifth Ave.

The washing instructions for the Scout uniform read: "The cloth should be washed in luke warm water, with a soap similar to Ivory or any other which does not contain much alkaline matter. Lay the garment on a board, scrub thoroughly with a coarse brush. Do not under any circumstances rub the soap directly on the khaki, as this is injurious. Rinse, first, in warm water, and then in cold water, to which at least two (2) cups of coffee grounds have been added, which will help to maintain the original appearance of the khaki cloth."

The Kanohwahke Scout Camps served as Monmouth County Council's first organized summer camp from c. 1918 to 1921. This 1920 summer camp promotional booklet promised that just one day at Kanohwahke Lakes would be "fifteen hours packed full with the healthiest, happiest, jolliest program that a boy can crowd into a summer's day."

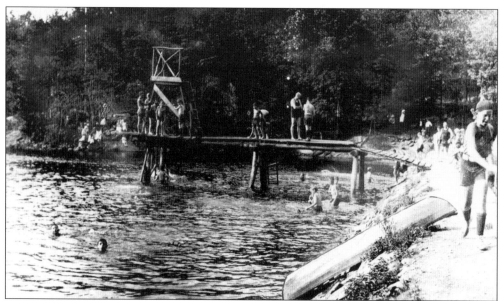

This waterfront scene may have been at the Kanohwahke Scout Camps. Located in the mountains of Harriman State Park, New York, the camp was developed by a federation of a dozen New York and New Jersey councils. Monmouth County Council was a minor player in this venture (the New York City councils were the prime movers), but Scout Executive Merritt L. Oxenham did have a seat on the camp's "Scout executive's council."

Scouts are ready to camp as often as they can find an adult to drive the truck. Pictured are members of Troop 12, Red Bank, on their way to camp in the 1930s. The records for Troop 12 go back to 1929, and the troop lasted into the 1960s. Over the years, it was sponsored by the West Side Branch of YMCA and by St. Thomas Episcopal Church.

This diagram shows how the Boy Scouts of America thought the well-dressed Scout of 1925 should look. Compared to the Eagle Scouts below, you can see that reality was not too far from the idealized image projected by the national organization.

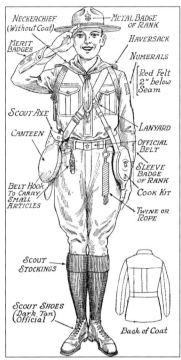

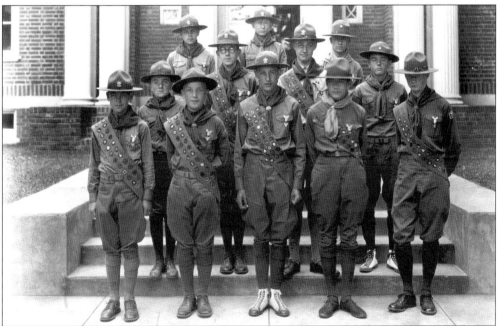

This c. 1925 photograph shows a gathering of Eagle Scouts, Monmouth's finest. From left to right are the following: (front row) unidentified, F. Lupton White (Troop 67, Red Bank), Hans Kessler (Troop 26, River Plaza), Henry Kaftel (Troop 7, Asbury Park), and unidentified; (middle row) Henry Kirk (Troop 17, Red Bank), Albert E. Sidwell Jr. (Troop 2, Asbury Park), unidentified, and Pierre Baylis (Troop 7, Asbury Park); (back row) unidentified, unidentified, and Laird Wooley.

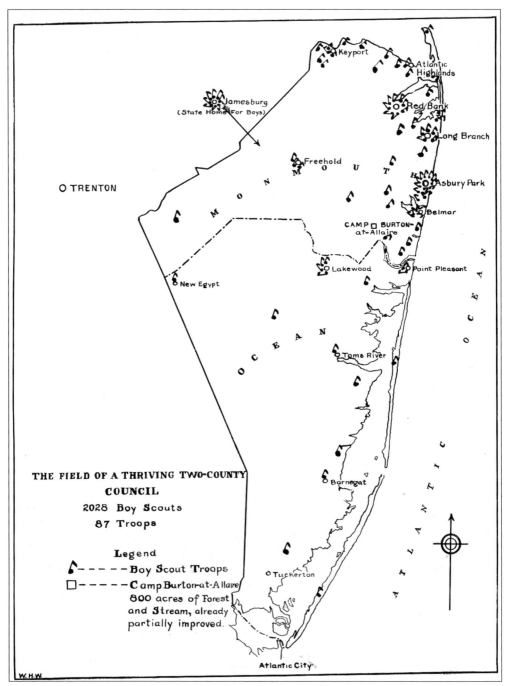

This 1930 map shows the extent of the council after Ocean County was added in 1927. There were just 16 troops in Ocean County. Records indicate they camped at Camp Burton-at-Allaire, as well as at other campsites. In 1939, the Ocean County area split from the council to form Ocean County Council 341.

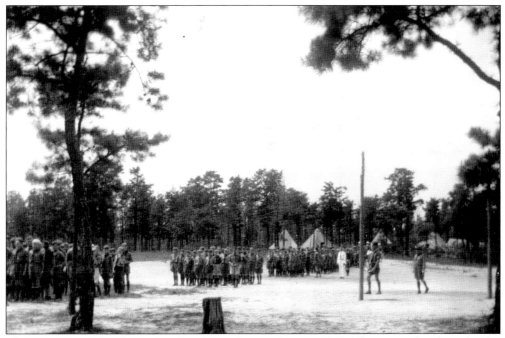

This was a typical sight at the first Camp Burton (1924–1928). The troops lined up for the morning colors and inspection at the parade grounds. This camp was located in Ocean County on the southern branch of the Metedeconk River in Adamston between Bay Head and Laurelton.

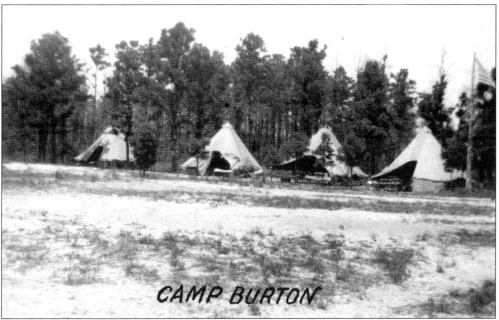

This August 1925 photograph offers another view of the tents at Camp Burton. The pyramid-shaped tents were big enough for a whole patrol of eight boys. This type of tent is also seen in military encampments of the same period. In the early days of Scouting, troop identities were not always retained at summer camp, but instead the Scouts were grouped into impromptu patrols as they arrived at camp.

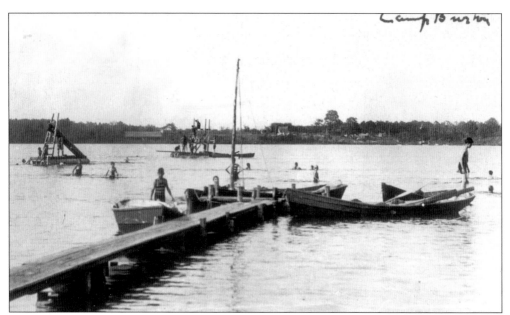

Swimming and boating in the Metedeconk River were top-rated summer camp activities at Camp Burton. The council retained title to the Camp Burton property until 1935, when it was sold to a real-estate developer. (Photograph courtesy of the Blair family.)

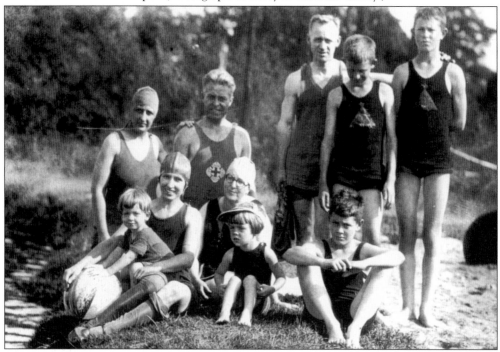

These guys and gals are taking a break from swimming at Camp Burton. The three boys on the right are, clockwise from the bottom, Charles, Tom, and William Blair. Tom and William have some kind of emblem on their suits. It appears to be a tepee design, which is reminiscent of the Camp Burton-at-Allaire felt-on-felt patch illustrated in chapter 3. (Photograph courtesy of the Blair family.)

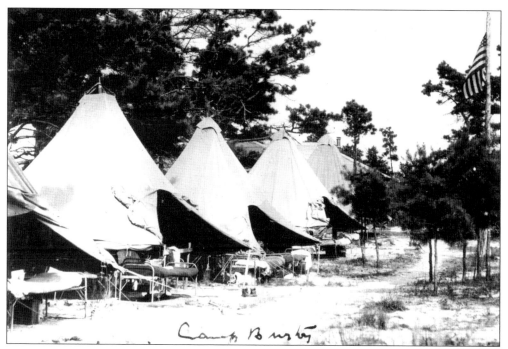

Camp Burton was named in memory of Stella Housman's son George Burton, who died in France. Frederick and Stella Housman donated the property for the camp, and George Burton's grandmother Mathilda Steinam donated the dining hall. (Photograph courtesy of the Blair family.)

These cabins were constructed at Camp Burton for the camp officials and staff. (Photograph courtesy of the Blair family.)

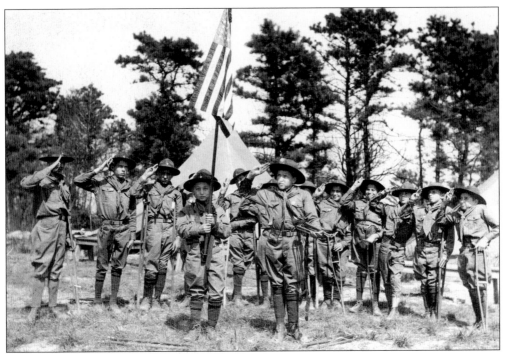

This photograph offers an unusual sight—an early troop of physically handicapped Scouts at Camp Burton. Through the years, Scouting has been supportive of boys with physical or mental handicaps. While some handicapped Scouts join "regular" troops, there are also troops that specialize in helping these Scouts reach their potential, such as Troop 230 in Keyport and Pack and Troop 454 in Freehold.

Monmouth-Ocean Council sent a contingent to the 1937 National Jamboree. Note that the wall tents have an interesting double roof, not unlike a modern nylon tent. Positioned near the entrance and with metal cots, these were probably the adult leader's tents. Behind them are the same kind of pyramid-shaped tents used at Camp Burton and Burton-at-Allaire.

The Scouts in the Monmouth-Ocean Council contingent gather with an unidentified visitor at the campsite's gateway at the 1937 National Jamboree. This was the very first jamboree on U.S. soil, and appropriately, it was held in Washington, D.C. It had been planned for 1935, but a polio outbreak caused it to be postponed.

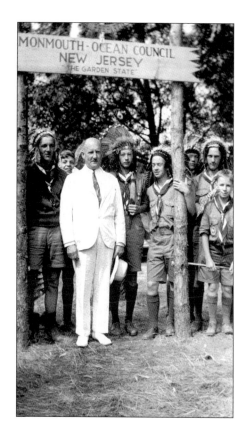

A Scout gets a cool drink of water at the 1937 National Jamboree.

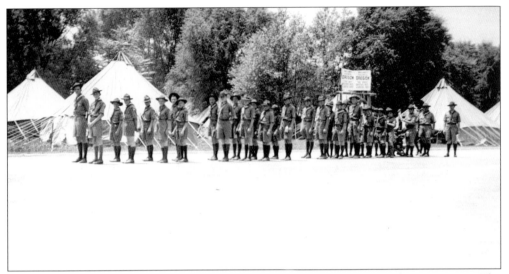

A tradition at the jamborees is for each council to erect a gateway to their campsite. The photographer snapped this shot of the Monmouth-Ocean Council contingent as they paused in front of the Oregon gateway on their way to an activity. While at the jamborees, Scouts visited the Smithsonian museum, Annapolis, Mount Vernon, the Capitol, professional baseball games, and arena shows.

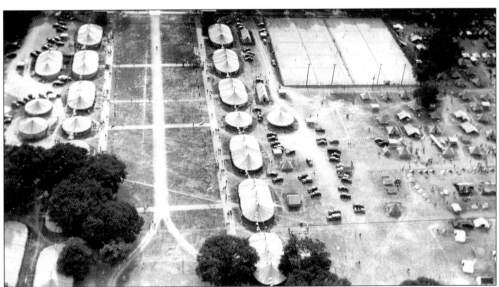

An aerial view of the 1937 National Jamboree in Washington, D.C., shows the national headquarters area. This picture initially puzzled the author—how did the photographer get access to an airplane? The answer: the picture was taken from atop the Washington Monument.

Two

THE ALLAIRE CAMPS

CAMP BURTON-AT-ALLAIRE

In the fall of 1928, Arthur Brisbane leased 800 acres, including the "deserted" Allaire Village, to Monmouth Council for $1 a year. Service clubs, churches, prominent businessmen, and Scouters refurbished the ironworking village's buildings and constructed troop campsites adjacent to the village. The Belmar Kiwanis Club set up an athletic field in a meadow near the campsites. The foreman's cottage was renovated by St. James' Church, Red Bank, and served as the camp hospital, or infirmary. This small building was also used as a cabin by troops camping at Burton-at-Allaire in the off-season. The village's large general store was restored by the Asbury Park Kiwanis club and was afterward known as Kiwanis Lodge. A shower house was donated by Leonard Newman of Spring Lake.

Camp Burton-at-Allaire opened in 1929. Gov. Morgan Larson attended the dedication of the camp on July 28, 1929. The summer camp program ran for the eight weeks of July and August. It drew Scouts from at least five different New Jersey councils. Scouts generally stayed at camp for a two-week period, for which they paid $6 (later, up to $8) a week. The camp was open year-round for weekend camping, training, camporees, rallies, and so on. The camp was also used by other groups, including the Girl Scouts, 4-H Club, Masons, and state farm agents. In 1930, the council's office relocated from Red Bank to one of the buildings in the village.

The camp operated successfully for over a decade. Following Arthur Brisbane's death, the council lost the use of the property, and the 1940 season was its last. Shortly thereafter, America was plunged into World War II, and any plans for a replacement camp were temporarily shelved.

Additional scenes of Camp Burton-at-Allaire may be found in *Images of America: Allaire*.

CAMP HOUSMAN

Following World War II, philanthropist Geraldine Thompson persuaded Phoebe Brisbane to donate 285 acres of the Allaire property along Hurley Pond Road to Monmouth Council. In memory of her husband, the camp was named the Arthur Brisbane Memorial Boy Scout Training Camp, which was usually shortened to Camp Brisbane. By the spring of 1947, 10 Adirondack-style log lean-tos had been built. Soon after, the council received a substantial amount of money from the estate of Frederick Housman for camp improvements. As a result, the camp also acquired the name Camp Housman Training Center.

Camp Housman was used only for weekend camping and short-term training. The permanent facilities included the ranger's house and garage, an all-faiths chapel donated by the Kiwanis, Pine Hollow cabin, 11 lean-tos, and several latrines. The stream was dammed to create a small swimming hole. There were many forest tent-camping sites as well as cleared fields for games and group activities.

When Quail Hill opened in 1967, Camp Housman was closed and the land became part of Allaire State Park. Nearly all remnants of Camp Housman are now gone.

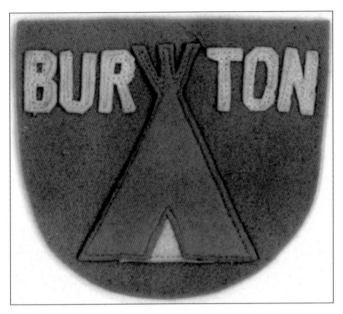

This is the only known example of the Camp Burton-at-Allaire felt-on-felt emblem. The background is green, the tepee is brown, and the lettering is white. Two other patches are known. One design, from c. 1939, is a simple blue-felt letter B. The other design, from c. 1931, is a C enclosing a B. All Burton-at-Allaire patches are exceptionally rare.

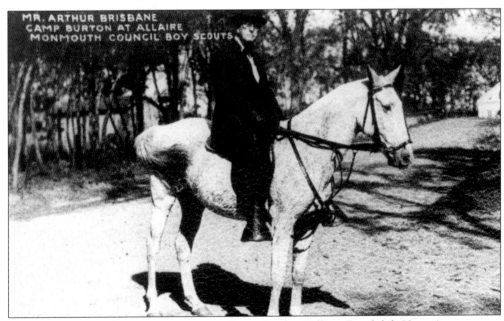

Arthur Brisbane was a nationally known editorialist for William Randolph Hearst's newspaper empire. In late 1928, he leased 800 acres, including the village, to Monmouth Council for $1 a year for 20 years. However, the council was expected to pay the taxes on the property. Brisbane died in 1936; the council lost the use of the property, and the 1940 summer season was the last.

The famous Allaire chapel (above) was in dire condition when the Boy Scouts of America obtained the property. The chapel, including its unusual belfry on the "wrong" end, was renovated by the Asbury Park Elks for $11,000, including installation of a new bell in the steeple (right).

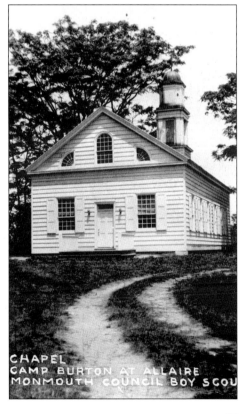

CHAPEL
CAMP BURTON AT ALLAIRE
MONMOUTH COUNCIL BOY SCOU

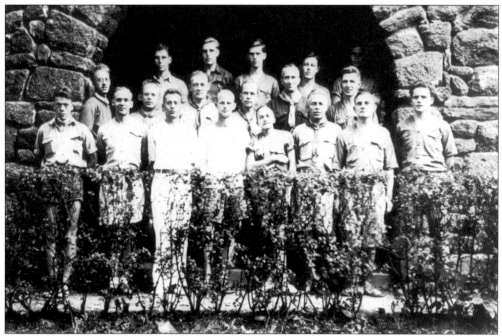

This picture shows the Camp Burton-at-Allaire staff in 1931. The man sixth from the left in the front row is probably Morgan Knapp, who was the assistant Scout executive. The stone arch is part of the porch on the camp headquarters. (Photograph courtesy of the Blair family.)

TENTS - CAMP BURTON AT ALLAIRE
MONMOUTH COUNCIL BOY SCOUTS

The campsites were located roughly in the area where the parking lot for the Allaire Village is now. The army-type tents were like those used at the first Camp Burton and were probably the same tents.

At the closing retreat on the last day of the 1930 season, the bugler fainted just as he finished playing taps. Upon being revived, he commented, "Gee, but it was hot!" This picture was taken the following year. (Photograph courtesy of the Blair family.)

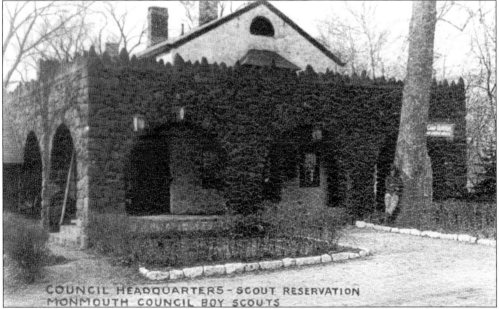

COUNCIL HEADQUARTERS - SCOUT RESERVATION
MONMOUTH COUNCIL BOY SCOUTS

The camp and council headquarters were located in this building—originally the village's carpenter shop. Before the Boy Scouts occupied the village, William DeLisle operated the Allaire Inn here. In the early 1900s, a kitchen was added on the right side of the building, a pavilion for dancing was built on the left side, and a stone porch was added in front. These additions no longer exist.

The camp's dining hall was in the former Allaire Inn's dance pavilion. The council was fortunate that the village had a kitchen and dining hall building ready-made for the camp. Most pictures of the campers show very little insignia on their uniforms; if any, it was just the

community strip and troop number. This may have been due to the economic constraints of the Depression and helps explain the rarity of Camp Burton-at-Allaire patches. (Photograph courtesy of the Blair family.)

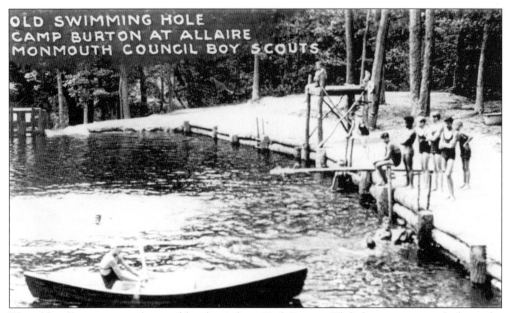

OLD SWIMMING HOLE
CAMP BURTON AT ALLAIRE
MONMOUTH COUNCIL BOY SCOUTS

The old mill stream was dammed by the Asbury Park Rotary Club for a swimming hole, and a lookout tower and diving board were installed. This pond was on the opposite side of the road from the current pond in the village. There was a totem pole next to the pond. In 1940, a Scout wrote: "This totem pole tells of the history of Camp Burton. . . . And last on top of the totem pole is the 'Eagle,' the ambition of every Boy Scout to become an Eagle."

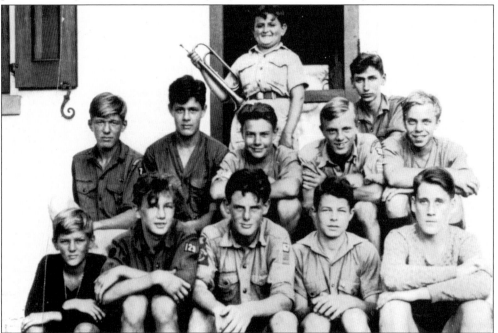

The Scouts at Camp Burton-at-Allaire did most of the same things as Scouts do today: hiking, swimming, arts and crafts, campfires, sports, and Native American lore. Skills that have all but disappeared included tracking and signaling. Although the Scouts could earn merit badges, there were no scheduled classes. (Photograph courtesy of the Blair family.)

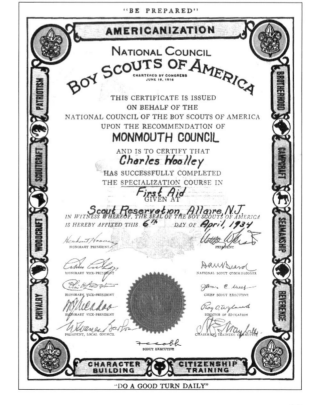

24. **ADVANCED PIONEERS**
2ND. DEGREE

UNION VILLAGE - CAMP BURTON

SCOUT: Ray Lorey TRP.# 5-5

HAS BEEN AWARDED 2ND. DEGREE

SIGNED: J W Clements.
CHIEF RANGER

Camp Burton-at-Allaire welcomed Scouts and troops from a number of New Jersey councils. As shown by this certificate, Union Council used Burton-at-Allaire, as did Raritan Council, Orange and Maplewood Council, Burlington Council, and possibly others. Union Council used the camp in at least 1932 and 1933.

"BE PREPARED"

AMERICANIZATION

NATIONAL COUNCIL

BOY SCOUTS OF AMERICA
CHARTERED BY CONGRESS
JUNE 15, 1916

THIS CERTIFICATE IS ISSUED
ON BEHALF OF THE
NATIONAL COUNCIL OF THE BOY SCOUTS OF AMERICA
UPON THE RECOMMENDATION OF

MONMOUTH COUNCIL

AND IS TO CERTIFY THAT

Charles Woolley

HAS SUCCESSFULLY COMPLETED
THE SPECIALIZATION COURSE IN

First Aid
GIVEN AT

Scout Reservation, Allaire, N.J.

IN WITNESS WHEREOF, THE SEAL OF THE BOY SCOUTS OF AMERICA
IS HEREBY AFFIXED THIS 6th DAY OF *April, 1934*

PATRIOTISM · SCOUTCRAFT · WOODCRAFT · CHIVALRY

BROTHERHOOD · CAMPCRAFT · SEAMANSHIP · REVERENCE

CHARACTER BUILDING · CITIZENSHIP TRAINING

"DO A GOOD TURN DAILY"

In addition to its use as a summer camp, Burton-at-Allaire was also used for weekend training courses and year-round troop camping. During 1930, troops from nine New Jersey and two Pennsylvania councils camped there, and patrol leader and Scout skill training was given for 2,000 Scouts. This certificate was for adult first-aid training held in April 1934.

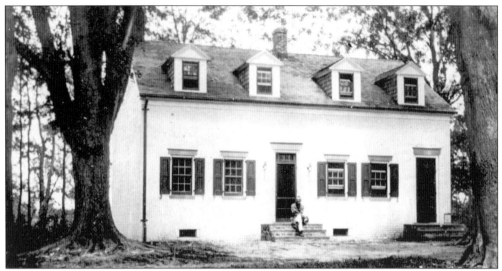

A short section of the worker's row houses was all that was standing in 1928. This picture shows the row house after it was restored in 1930. The council office moved from Red Bank to the Allaire Village in March 1930. Both this building and the former carpenter shop constituted the "headquarters" of the council and the camp.

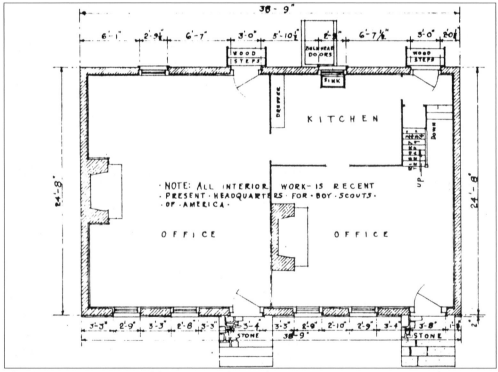

The Historic American Buildings Survey (HABS) was a Depression-era government project that put draftsmen to work creating architectural renderings of historically significant buildings across the United States. This drawing of the row house is from the HABS survey done in the early 1930s. The draftsman noted that this building was in use by the Boy Scouts of America as the headquarters. (Drawing courtesy of Allaire Village Inc.)

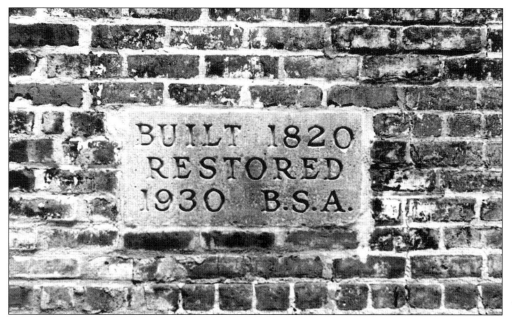

One of the few remaining indications of the Boy Scouts of America's restoration and use of the Allaire Village, this stone marker can be seen on the wall of the restored worker's row houses that are used as the visitor center for the village.

This photograph was taken on Governor's Day at Camp Burton-at-Allaire, August 4, 1940. Gov. A. Harry Moore visited the camp. This was the last year of operation of the camp.

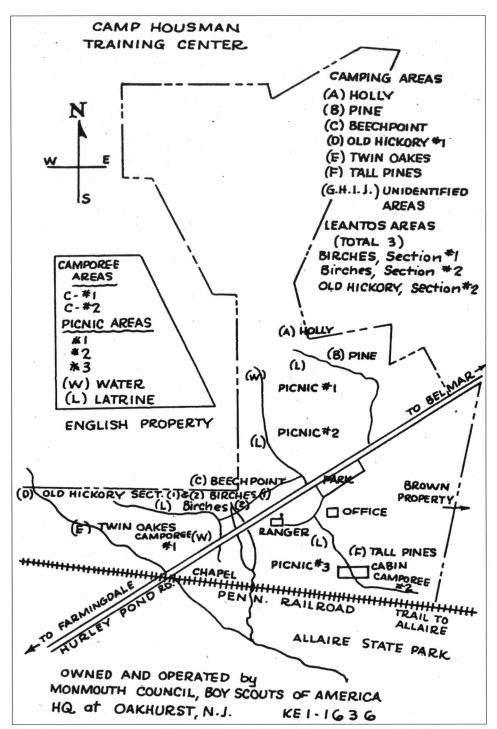

Although it is not apparent on this *c.* 1962 map of Camp Housman, parts of the Housman land were swampy and unsuitable for camping. In addition to the Boy Scouts of America property, Scouts could hike the trails of the adjoining Allaire State Park. Once Quail Hill Scout Reservation opened, the Camp Housman land was added to the state park.

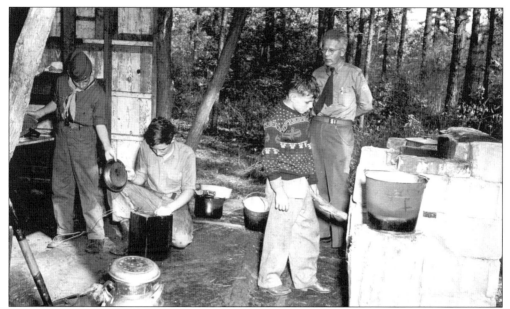

Troop 50, Shrewsbury, camped in one of the Adirondack-style lean-tos at Camp Housman. In this view, Bob Jenkins (left) and John Newman wash pots, and Alfred Beadleston Jr. stokes the fire while Scoutmaster Robert Disbrow supervises. All camping at Housman was in either tents or lean-tos. Water was carried from a central well, and troops dug their own latrines. Later, permanent latrines were available.

The Camp Housman flagpole was dedicated on May 30, 1949. It was donated by the Monmouth chapter of the Daughters of the American Revolution in memory of three former Scouts who gave their lives in World War II and who were members of the Mary Stillwell Society Children of the American Revolution. They were Sgt. Spafford W. Schanck Jr. of Matawan, Pvt. Robert B. Campbell, and S2c. Eric Parmly Jr.

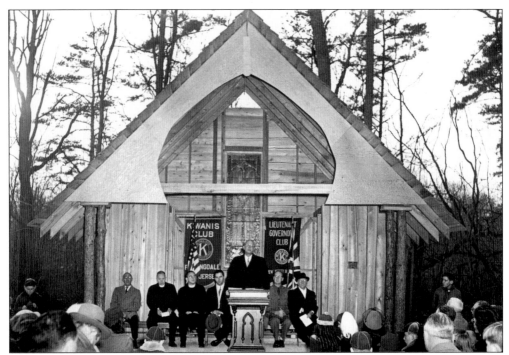

The all-faiths Kiwanis Woods Chapel was dedicated at Camp Housman on December 7, 1952. The invocation was led by Canon Raymond Miller, St. Uriel's Protestant Episcopal Church, Sea Girt. The address was given by Rabbi Paul Levritz, Lakewood. E. Donald Sterner and Kendall H. Lee accepted the gift of the chapel on behalf of the council from Division No. 4, New Jersey District of Kiwanis International.

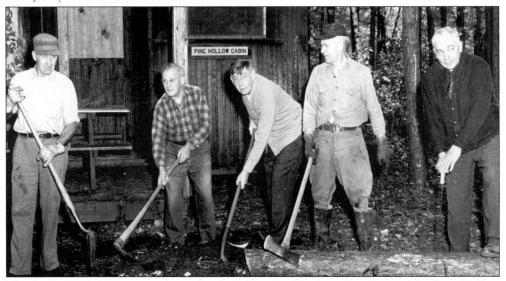

The Beaver's Club (the equivalent of today's Campbuilders) work in front of the Pine Hollow cabin at Camp Housman in 1948. On that weekend, 15 men and 15 Scouts dug new ditches and cleaned old ditches. In this picture are, from left to right, unidentified, unidentified, W. Harold Warren, Stanley Green, and Ranger Carl Thunnel. Other rangers were Irving Culver, Jim Werner, and Tom Morley.

Three

FORESTBURG
SCOUT RESERVATION

After Camp Burton-at-Allaire closed in 1940, the council made arrangements each year for troop summer camping at other Scout camps, including Pine Hill, Pahaquarra, and Cowaw. The council also looked for a suitable parcel of land to purchase for a mountain camp. In the early 1950s, as the search committee was returning from a trip into New York, the group stopped for dinner at Homer's restaurant in Port Jervis. While discussing the merits of the property they had just seen, a diner at the next booth suggested they look at the nearby estate of Dr. Thomas Darlington. The committee was impressed with the property, and soon thereafter, a deal was struck to purchase it. On May 18, 1956, the council purchased the 525-acre estate from his widow, Florence Darlington, for $78,000. Attached to the deed, Billett found a check from Florence Darlington in the amount of $20,000 to help fund the development of the camp.

On June 24, 1956, the camp opened for the "pioneer" season with J. Fred Billett as camp director. His son James was the camp bugler. Few improvements had been made; the nearest telephone was two miles away at a neighbor's house, and there was no electricity except for a generator that powered the well pump. That year, the campers ate their meals in the existing dining facilities of the estate-camp. In 1957, the present dining hall was built with the support of many of the county's service clubs, and troops began camping at the Dan Beard camps. In 1960, the Central Camp fee was $22 a week or $19.50 for a week as a "self-sufficient" Dan Beard camper.

In the 1960s, purchases of additional parcels, including 450 acres on Metoque Mountain in 1964 from the Metoque Hunt Club, put the total acreage over 1,200 acres.

Originally, the permanent facilities were only at the Central end of the lake, so Dan Beard campers paddled their canoes to Central to pick up their food each day. This is the origin of the "canoeist" as the Dan Beard logo. In 1966, Todd Lodge and Rogosin Lodge were built, and thereafter, the campers made their food pick-ups at Rogosin Lodge. Through the 1970s, the Dan Beard campsites still had their own small docks with a rowboat and canoe. During the Sunday evening opening campfires on each end of the lake, a friendly rivalry developed over which campfire was louder. The two rival camp staffs frequently competed in basketball, volleyball, and pranks.

There have been four rangers at Forestburg: Tom Morley, Norwood "Red" Gray, Ronald Frick, and John Horvath. The ranger's family lived in the small house by the parking lot that is now called the Bear's Den. In 1983, a new ranger's house of log construction was built.

This was the original estate lodge as it looked in May 1956, when the Darlington property was purchased. It served as the camp headquarters. On the first floor were the camp director's office, health clinic, kitchen, and a lounge with a fireplace. Staff quarters were on the second floor. The lodge burned down in the early 1970s. It stood where the Pollak Health Lodge now stands.

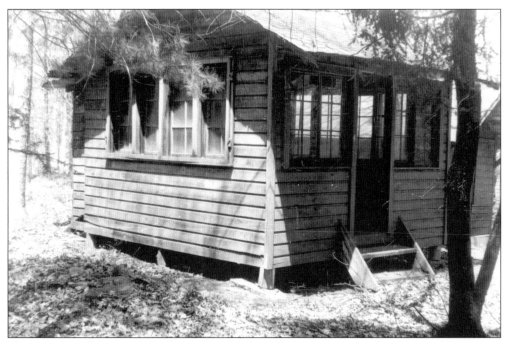

This was one of the original cabins from the days of the Darlingtons. Dr. Thomas Darlington operated a camp at the estate, where he brought people with severe respiratory problems from New York City for the fresh air. One of these cabins still stands behind the dining hall as a utility building.

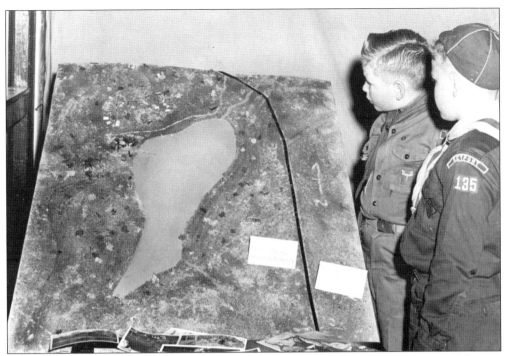

This diorama was made to promote the new camp to prospective campers and financial donors. Bill Burket remembers seeing it at the Scout shows at the Asbury Park Convention Hall.

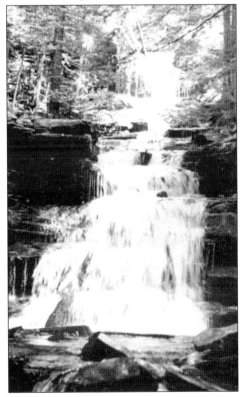

A natural feature of the camp, the Darlington Falls are named in memory of Thomas and Florence Darlington. A hike to the falls for a "shower" is a highlight of the week at Forestburg. This postcard may predate 1956 because it calls the property "Camp Forestburg," a name that was not generally used by Monmouth Council.

The Housman Memorial Lodge, informally known as "the dining hall," was dedicated to Frederick Housman. The building was a gift of Frederick and Stella Housman. An oil painting of Housman hangs here. Housman was an early council president and a lifelong supporter of Scout camping. The trusses used to construct the Housman Memorial Lodge were recycled from a chapel at Fort Monmouth. The kitchen is named Dave's Philmont Kitchen, in honor of Scouter Dave Nugent, who gave up going to Philmont in order to be the camp cook. The totem poles, which have graced the front facade since the early 1960s, were carved by Tom Morley.

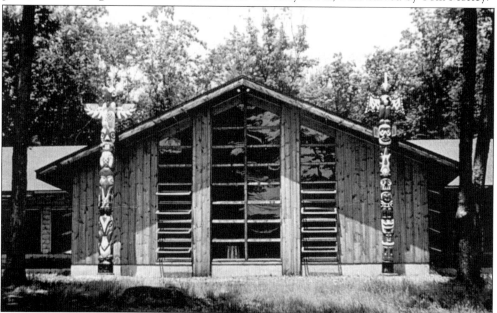

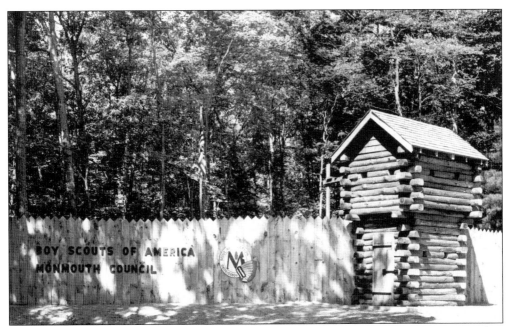

The stockade at the entrance to Forestburg on Route 42 is an iconic feature of the camp. Before the highway was relocated, it ran right next to the stockade that served as the camp's mail drop. The stockade is just opposite the spot where Joseph Brant, whose Native American name was Thayendanegea, camped following a raid on July 20, 1779, on Minisink (Port Jervis). The stockade is a memorial to Lt. John S. Mark of the U.S. Navy.

This is one of the first Forestburg Scout Reservation postcards. The July 29, 1957 message reads, "Dear Aunt Sally and Uncle Bill, How are you all! We are having a swell time swimming, boating, fishing, and hiking. 28 boys from our troop, and another leader came with us. Ken will stay till Aug 4th."

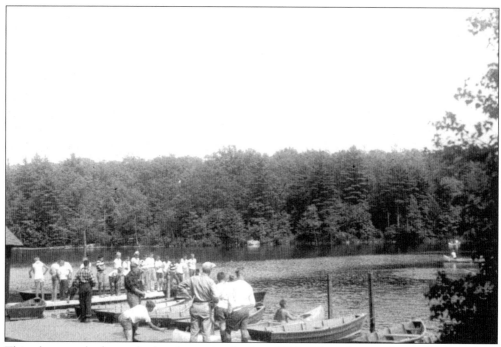

This photograph shows the boathouse in the late 1950s. Note the wooden rowboats, which were replaced by aluminum boats as they wore out. The boathouse was located across from the trading post, where the Wilkinson Program Center now stands.

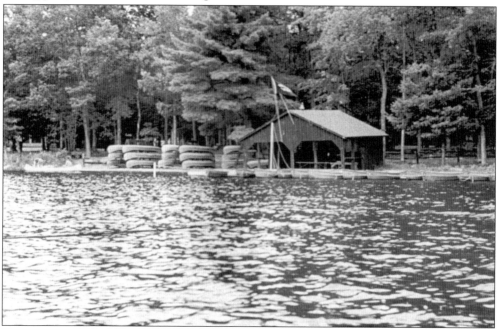

Shown is another view of the boathouse. These boats were used by the Central campers. The Dan Beard campers had boats at each campsite, and their paddles and floatation devices were kept at the Scoutmaster's tent. In theory, the boys were supposed to have his permission to use the troop's boats.

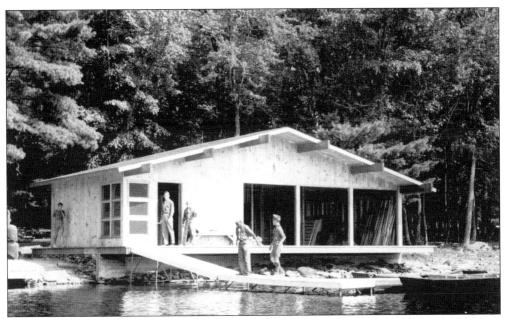

The original boathouse was replaced by a more substantial and somewhat larger building. It originally served the same purpose, although it is now called the Wilkinson Program Center and has been used over the years as a Scoutmaster lounge, camp office, and most recently, the residence for the dining hall staff.

As they entered the dining hall, the Scouts deposited a letter or postcard to be mailed home to family or friends. Besides being good public relations for the camp, writing the letter helped to ward off homesickness. The first Na Tsi Hi Lodge Order of the Arrow flap patch can be seen on the shirt of the fellow holding the camera.

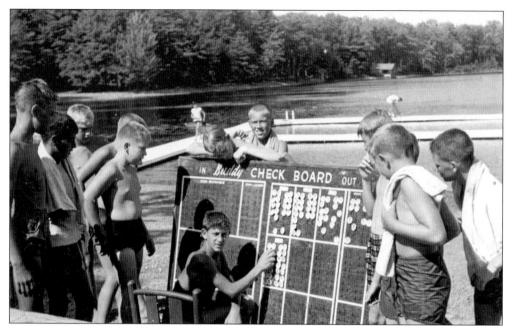

A staff member explained to the campers how to use the "buddy board." Each boy was given a tag with his name on it, and the boys would put their tags on the board in pairs to indicate their swim partners. This allowed the lifeguard to tell by a glance at the board how many pairs of Scouts should be in the swimming area.

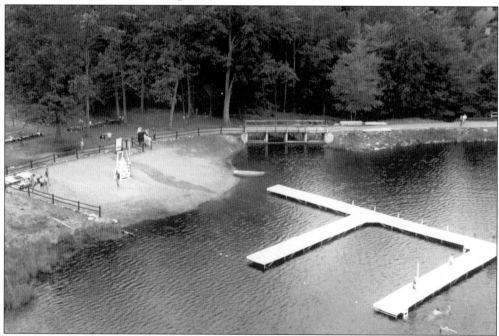

This bird's-eye view shows the F dock at the Central Camp waterfront. Because the original Hope Lake was not deep enough, the dam visible in the upper right was constructed. The lake has also been dredged; some large tree stumps are still visible along the shoreline, where they were left by the heavy equipment.

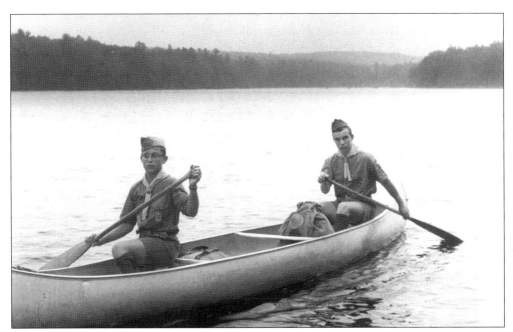

Russell Vorhees (left) and Richard Olfeldt of Troop 69 enjoy paddling on Burnt Hope Lake. The lake's name comes from the name of the Hope Lumber Company, which once logged the whole area. There were at least two major forest fires through this area; thus, the lake is known as Burnt Hope Lake.

This evening retreat ceremony looks almost the same as today, including the well-uniformed staff, the bugler, and the color guard. Note that there is only one flagpole. The second and third flagpoles were installed in 1959. The flagpoles and cannon were donated by the Chingarora District commissioners.

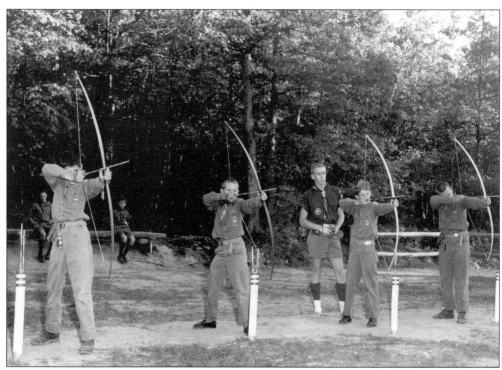

Archery at the Field Sports area has always been a popular activity at summer camp. The Scouts are waiting for the range officer to give the command before they begin shooting.

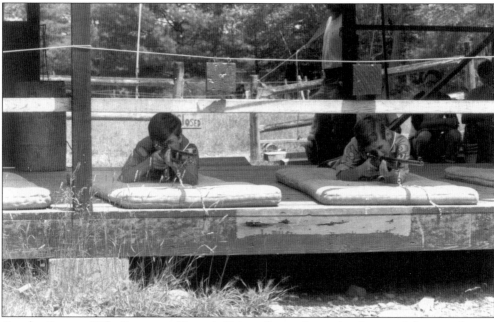

On the Sterner Rifle Range at Central Camp, Scouts learned safe use of firearms from a National Rifle Association–certified range officer. The prone position (lying down) helps stabilize the .22 rifle and so results in higher scores than shooting while standing up. Today, the Scouts are provided with eye and ear protection.

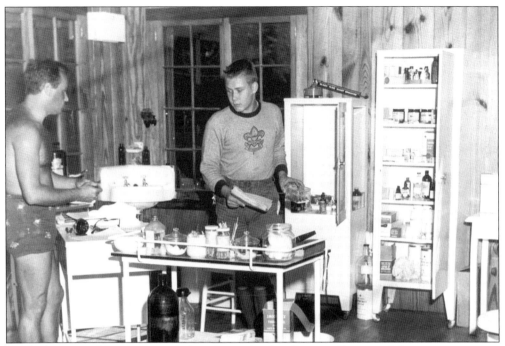

Inside the original headquarters lodge, the medical staff was well prepared for any emergency.

Other than a few details like the canvas knapsack and the old handbooks the boys are reading, this scene could be 1960 or today. Part of the appeal of summer camp is getting away from home and enjoying a different pace of life.

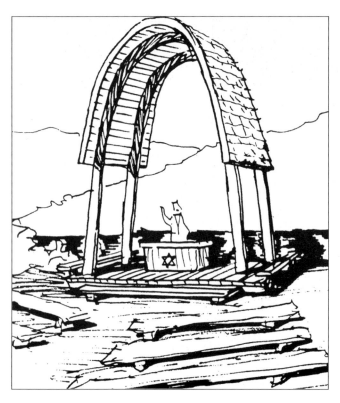

This artist's rendering shows the Jewish Chapel. The chapel was built by the Jewish War Veterans of Monmouth and Ocean Counties and was dedicated on July 28, 1968, in honor of Harry Feldt of Fair Haven, a distinguished Scouter who helped get the chapel built. It was dedicated a second time on July 10, 2002, in honor of 1st Lt. Howard Jon Schnabolk, an Eagle Scout from Troop 58. As an army aviator, he gave his life for his country in the Vietnam conflict.

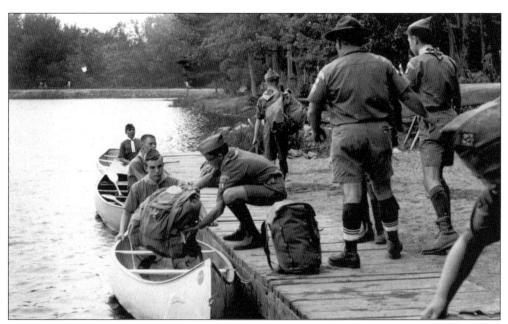

Scouts load packs into their canoes for the trip across the lake to Dan Beard Camp. Use of life preservers was not mandatory. This may have been the daily "food pick-up" trip from Dan Beard to Central that was required before the facilities at Dan Beard were constructed in 1966.

50

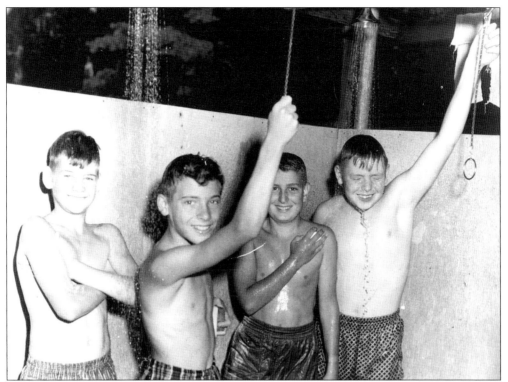

A Scout is clean. The Scouts got a daily shower in the Central Camp shower house, donated by the Dorn family. This shower house was finally replaced by a grand new facility in 2002.

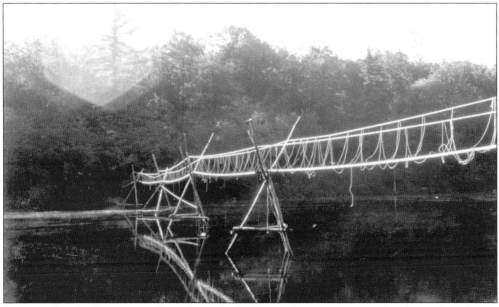

The monkey bridge crosses Hope Lake from the picnic area adjacent to the parking lot at Central to Perch Rock. Construction on the bridge began in 1981, but it was first open to Scouts in 1982. A shorter monkey bridge was also built across the lake near Todd Lodge in the early 1970s.

51

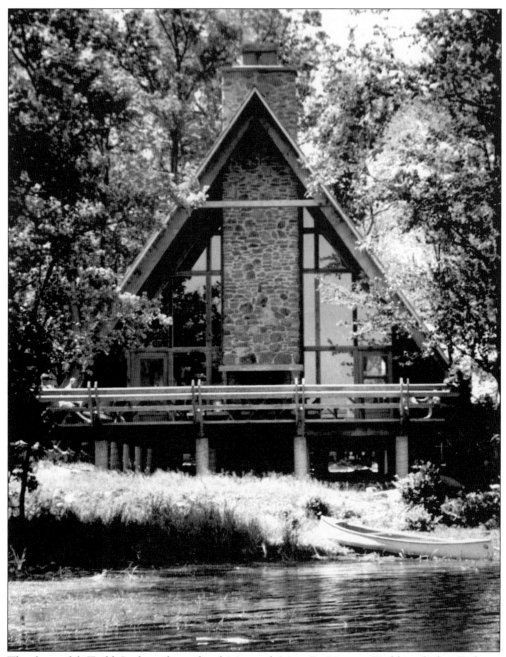

The beautiful Todd Lodge, the gift of Mr. and Mrs. E. Murray Todd and the Bodman Foundation, is the headquarters for the self-reliant Dan Beard Camp. Downstairs are the camp director's office, a kitchen, a lounge, and a deck for al fresco dining. Upstairs are two small bedrooms. In cold weather Todd Lodge can be very chilly, but in nice weather it has a million-dollar view of Hope Lake.

One of the Adirondack-style outposts is being built. The six outposts with lean-tos are Indian Ridge, Indian Springs, Jim King, Hunter's Point, Hemlock Pond, and Lookout Point. The latter was built by Na Tsi Hi Lodge in 1964–1965. The man in the middle of this picture may be Chingarora commissioner James Flynn.

The Native Americans were the first campers in North America. Scouting honors their cultures by teaching Native American crafts, foods, dancing, and respect for the Earth. Of course, tepees were not used by the original peoples of the Northeast, whose lodges were made of bark-covered bent sapling frames.

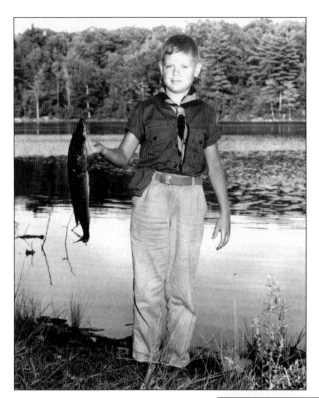

This Scout had a big fish story to tell when he got home in 1957, and he was fortunate to have photographic evidence that his pickerel was "this big."

Although summer camp brings to mind physical activities, it can also develop the brain. Through the efforts of David Fiedler, the new AFCEA High Technology Center was opened in 1997 in the room adjacent to the Central Camp (now Billett Camp) trading post. Merit badges such as Radio, Space Exploration, Electricity, and Electronics are offered there.

The correct use of a block and tackle for moving a heavy weight is demonstrated by Gary Casey (left) and Richard Hackenbury of Troop 143, Wanamassa. This is one of the skills needed for the Pioneering merit badge, along with knot tying, splicing, and lashing. They are in front of the Sterner Hike Center, which was built in 1966.

Two experienced Scouts prepared one of the burros for a pack trip. The camp owned two burros, who lived in a barn (no longer existing) located where the Dan Beard parking lot road meets Route 42. The ranger was frequently called upon to round up the burros when they got loose. Troops could use the burros on hikes to the outpost camps.

This 1991 picture of the Central Camp waterfront shows some changes. A guard tower has been built on the beach of the swimming area, and the boatyard has been moved from the boathouse to its current location next to the swimming area. The original F dock has been replaced by floating wooden docks.

The original camp layout, upon which this map was based, anticipated a series of troop campsites near the site of the Jim King outpost lean-to; the campsites were to be collectively called King Camps. This was the area at the top corner of the map. Another feature anticipated in the original design was a heliport at the Dan Beard parking lot.

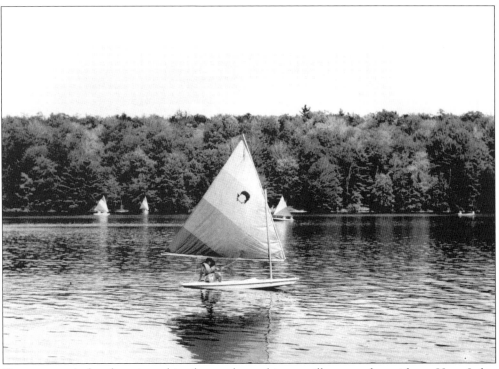

On a summer's day there is nothing better than taking a sailboat out for a ride on Hope Lake. This photograph of Forestburg Scout Reservation staff member Dave Wolverton of Troop 60, Lincroft, was taken in 1981.

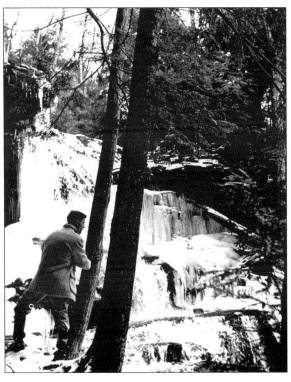

In the winter, the water flowing over Darlington Falls freezes and creates an impressive natural ice sculpture.

These members of the 1970 Central Camp staff are, from left to right, as follows: (front row) Bob Litowsky, Cliff Grohe, Michael Flannigan, Joe Child, David Mahoney, Dave Dorl, John Epps, Alfred Fraley, Dan Craig, and Ed Tripold; (middle row) unidentified, Art Flannigan, Mike Robertson, Bob Loversidge, Tom Dunlap, Thomas "Bear" Fraley (camp director), Doug Haneline, Doug Beer, Bill Bishop, and Guy Fraley; (back row) William Burket, Charles Morgan Jr., William Van Fleckmann, Bruce Iknar, unidentified, Bill Kinney, Al Aszman Jr., Bob Koenig, Bill Beck, ? Freedman, Jack Atwood, and George Engeldrum. (Photograph courtesy of Bill Burket.)

Members of the 2000 Forestburg staff monkey around for the camera. (Photograph courtesy of Jodi Stark.)

58

Four

QUAIL HILL
SCOUT RESERVATION

In May 1964, the council purchased the farm belonging to sisters Elizabeth and Grace LeValley on Locust Hill in idyllic Manalapan. The council had been using Camp Housman for weekend camping and training since the 1940s, but it was inadequate for the kind of outdoor programs that the council wanted to offer. Chet Fromm, a member of the council's professional staff, was assigned the task of developing the farm into a multiple-use camp to be called Quail Hill Scout Reservation. Ten "pioneer" troops were given the opportunity to camp there for the weekend of October 16–17, 1965, in conjunction with the groundbreaking ceremony.

Over the next few years, a significant transformation took place. The Ern Construction Company of Hazlet graded the roads and parking lots. Grass seed was sown in the fields. A drinking-water system was installed. Kiely Pond was dug by the Kiely Construction Company. The Freehold Township Lions Club donated the materials for the campfire ring, which was constructed by the Order of the Arrow. An all-faiths chapel was donated by the Red Bank Rotary Club. Scout Lodge, Webelos Lodge, and several latrines were built. Quail Hill was formally dedicated on October 7, 1967, during a big Scout fair held on the property. The turnout for the fair was so big that some visitors had to park their cars on Route 33.

Chet Fromm was a former army man who had been director of training and a district executive for the council. He supervised the creation of the camp and served as the first ranger. He retired in 1983. The subsequent rangers were George Leidy, John Herlihy, Randy Blades, and Jim Mechkowski. John Malcolm has served the camp for many years as a de facto volunteer assistant ranger.

Other additions to the property included the ranger's house and garages, the pool and pool house, the program shelters at Webelos and Scout Lodges, and the BB range shelter. In the mid-1980s, Lawrence Lodge was built. Many volunteers contributed time or money to the project, and apprentice plumbers from the local union hall on Route 33 assisted with the plumbing. The building was originally envisioned to be a training center, and with the recent construction of the Lass Lodge, it appears that that plan is coming to fruition. Lawrence Lodge is also the focal point of the growing Cub and Webelos summer camp program. One of Monmouth Council's notable achievements was the first Cub Scout day camp (at Quail Hill) in the Northeast.

As the western part of the county becomes more populous, the properties bordering Quail Hill are being transformed from farms to housing developments. The council purchased the Truempelman property bordering the pond in the 1990s to maintain the "woodland" vista in that area. The most recent construction projects have been a flush bathroom facility near the Webelos camping area (donated by the Order of the Arrow) and the Ernest W. Lass Program Center, built on the site of the original LeValley farmhouse. Both of these projects were substantially finished in 2002.

THIS IS MONMOUTH COUNCIL'S NEW CAMP
IN HISTORIC MANALAPAN TOWNSHIP,
MONMOUTH COUNTY

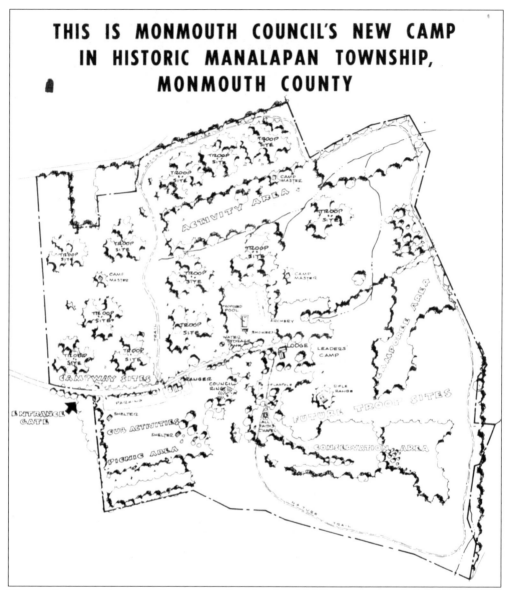

This is the original engineer's concept plan for Quail Hill that was used during the effort *c.* 1963–1965 to raise $265,000 to purchase and develop the camp. Many details changed as the camp was being built. The most obvious is the addition of the pond. The archery range was also repositioned so that a campsite was not in the line of fire.

Ranger Chet Fromm teaches a class on conservation and ecology at Quail Hill during a Scout leader training session c. 1970. After serving in the army, Fromm joined the professional service and was a district executive and camp director at Camp Housman. He then oversaw the development of Quail Hill and served as the first ranger. Although he had a gruff exterior, he was totally committed to the Scouting program.

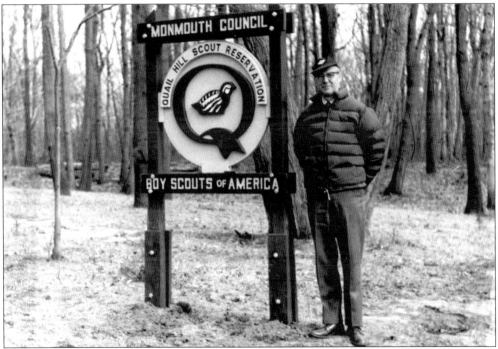

Dave Minott, a member of the original Campmaster Corps, helps show off the new Quail Hill sign.

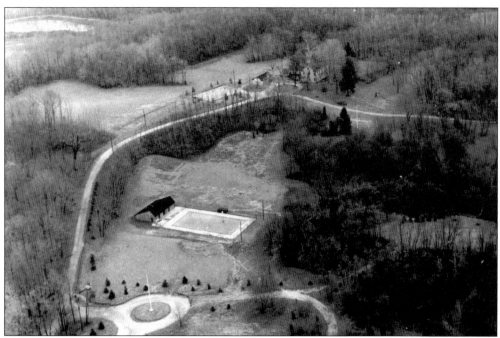

You can see in this aerial view from the late 1960s that even though Lawrence Lodge was not to be built until two decades later, the flagpole and parking lot were ready. Those little pine trees are a lot bigger now.

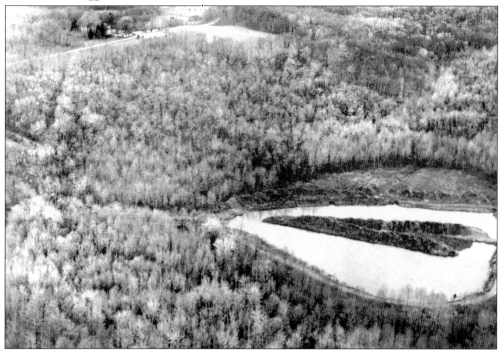

This aerial view looks toward the opposite direction from the man-made Kiely Pond. According to one story, the odd shape of the pond occurred because, while the pit was being dug by earthmoving equipment, rain caused it to fill with water before the workers were done.

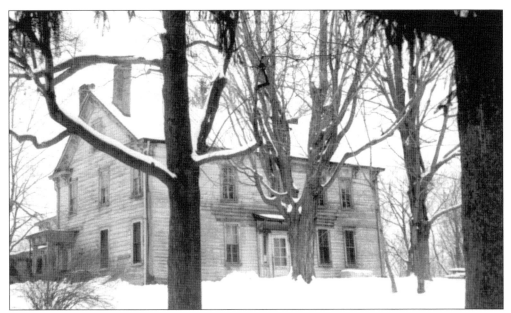

The LeValley House was the farmhouse for the LeValley farm, also known as Locust Hill. Built *c.* 1790, it was later remodeled by John Van Doren with Italianate architectural details. It housed the trading post, Scouter's meeting room, campmaster's office and bedroom, quartermaster, Order of the Arrow room, a dormitory-style bedroom, and storage rooms.

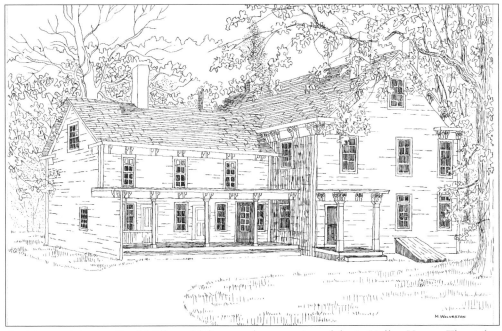

A visitor arriving at Quail Hill would first see the rear wing of the LeValley House. The right-hand door was the entrance to the camp office and quartermaster room. The upstairs rooms were used for storage. Margaret Wolverton created this ink drawing in the early 1990s.

The trading post was in the room on the right from the entrance hall in the LeValley House. It was always well stocked with camping equipment and literature. The fireplace mantel and wallpaper visible here show that the house was nicely finished when it was a residence. Kitty Fromm was usually on duty in the trading post.

The Scouter's room in the LeValley House was just across the hall from the trading post. This room was used for meetings and also had a small library and Chet Fromm's files on Scoutcraft. On Order of the Arrow powwow weekends, the lodge officers sometimes slept here.

This is a small barn from the farm, which was demolished in 1994. It was used for storage of camp equipment. Early Monmouth County maps show another, larger barn, as well as other farm buildings on the property, but by the 1960s, only a few foundation stones remained.

When the LeValley property was converted to be Quail Hill, cots and a wood stove were provided for four-season cabin camping in the garage next to the farmhouse. The author recalls staying in this building in the early 1970s, when it had a very dusty woodchip floor. It was renovated by the Order of the Arrow and named Devlin Lodge in 1978. There is a picture of Thomas Devlin in chapter 8.

The campfire bowl was built from scratch. The sod was laid by members of Na Tsi Hi Lodge in the spring of 1968. They also planted the trees along each side (not visible in this picture). The funds were contributed by the Freehold Township Lions Club.

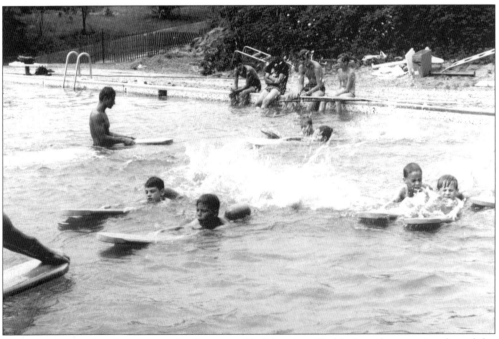

There was not quite time to get the fences and ladders installed before the opening day of the pool in July 1969. The boys enjoyed the pool nonetheless.

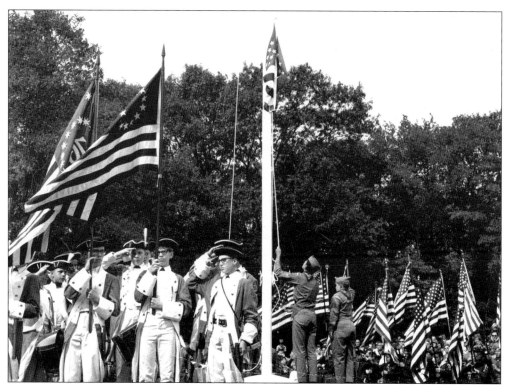

Quail Hill was dedicated during a big Scout fair in October 1967. Here we see the opening ceremony. The Joshua Huddy Fife and Drum Corps from Colts Neck is on the left. The camp opened for regular weekend camping in November 1967.

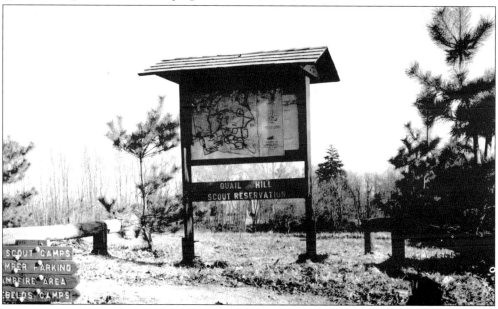

Upon entering camp, the visitor could consult the camp map. This photograph was taken from the middle of the circle in front of the present-day Lawrence Lodge, looking east toward where the pool was later installed.

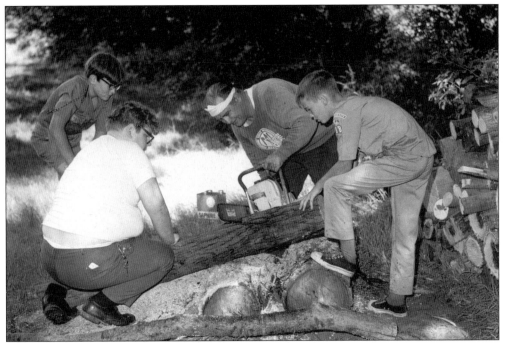

Pictured in the early days of Quail Hill, John Malcolm (center) shows the kids how to cut locust logs. Malcolm is still an active supporter of Scout camping and volunteers every weekend as a Quail Hill campmaster.

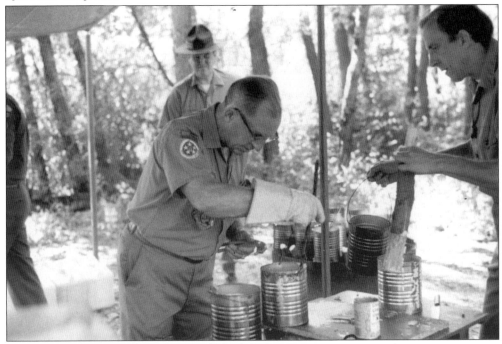

Gus Bogart (center) and Warren Insull (right) demonstrate tin can cookery at campmaster training in 1978. The founding members of the Quail Hill Campmaster Corps were Gus Bogart, Dave Minott, Al Westerfield, and Al Turner.

This view gives an idea of the amount of work it took to create the camp. The photograph shows the road down to Kiely Pond being cut through the woods in the spring of 1968 by Na Tsi Hi Lodge.

Quail Hill has been host to dozens, if not hundreds, of camporees. This one, at Site 3, is the Cowaw District of Thomas Edison Council in October 1974. Seventy-six adults and 295 Scouts participated.

Gus Koerner Jr. and a friend work on his Eagle project in the snow in January 1972. They are clearing trees along the edge of the woods road. Today, camp service projects are ineligible for the Eagle rank.

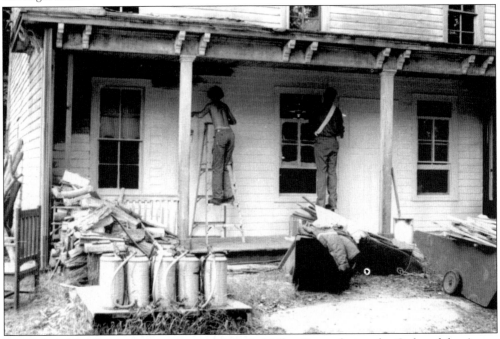

An Order of the Arrow work crew painted the LeValley House during the Order of the Arrow Fall Powwow in 1978. Each year at the powwow, various camp-improvement service projects are accomplished, from cutting brush, painting, and plumbing to maintaining the roads and trails.

Staff member Jim Thomas of Troop 125, Fair Haven, demonstrated plant and tree identification during troop leader training in 1980. The council's annual junior leader training course was held at Forestburg beginning in the early 1960s. In the mid-1970s, it was moved to Quail Hill and has remained a staple of the training curriculum at Quail Hill ever since.

Ranger Randy Blades Sr. (right) relaxes in the kitchen with John Malcolm in 1996. Blades retired in 2001 and now lives in upstate New York.

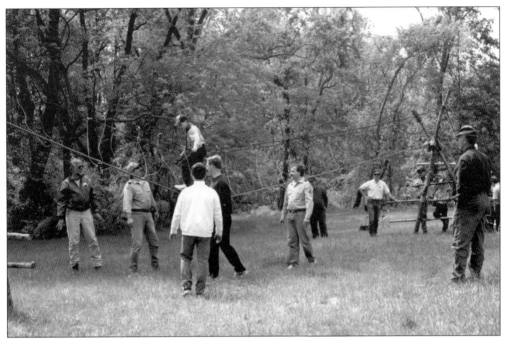

At the spring Webelos Woods event, Webelos Scouts and their parents get a taste of the Boy Scout program. At the pioneering station, each boy gets a chance to try walking across a rope monkey bridge. Webelos Woods started as an event sponsored by the Order of the Arrow.

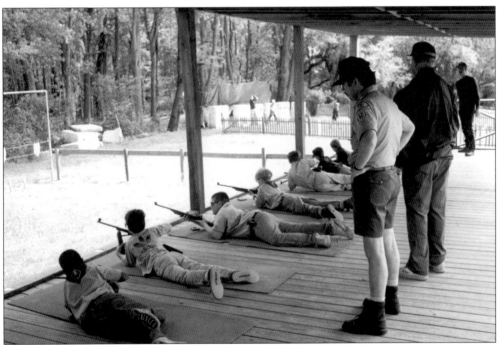

The BB and archery ranges at Quail Hill are available for use by packs and troops. A trained range officer must be present to ensure that all safety procedures are followed. The range officer on this day was Scouter Ed Semple (in shorts) with another unidentified campmaster.

Five

EVENTS

Every year, the Scouts and leaders of Monmouth Council participate in a wide variety of events, such as camping trips, camporees, Klondike Derbies, training courses, Scout shows, courts of honor, Philmont treks, and jamboree trips. Certainly, they could fill a book all by themselves. This chapter is a smorgasbord of these activities.

The earliest intertroop gatherings in the 1920s were usually one-day district rallies and field days. The Scouts would compete in fire starting, wall climbing, first aid, and so on. By the 1930s, these had evolved into a staged Scout show, in which the units would demonstrate their particular skills to an audience. Many of these shows were held in the Asbury Park Convention Hall. The show was presented on the stage or on the floor of the auditorium, while other units demonstrated more skills elsewhere in the hall. The last show at the Asbury Park Convention Hall was *c.* 1979.

By the late 1930s, the council was starting to hold weekend outdoor camporees, which were sometimes called Scout fairs. Eventually, the fair and the camporee merged into a single event. Typically, troops and posts would camp for the weekend and demonstrate their skills on Saturday, while the packs would attend just for the day. In the 1950s, the districts also began hosting their own district camporees. Both Central District and Chingarora District started the tradition of Klondike Derbies beginning in 1960.

The National Jamboree is probably the most significant gathering of Boy Scouts in the United States. It generally occurs every four years. Monmouth Council has been represented at every jamboree ever held since the first jamboree in Washington, D.C., in 1937.

A trek to the Philmont Scout Ranch in New Mexico is a highlight of any Scout's career. Opened in 1939, it was originally called Philturn Rocky Mountain Scout Camp. We do not know when the first Monmouth Council crew attended, but we know that Russell Tetley of Red Bank led a contingent in 1947. In a letter to his wife, he wrote: "In the last two days [out from base camp] we have really been over the mountains. Twelve miles yesterday and fourteen today—the borros are supposed to carry the bedding and the scouts the packs but the Camp Director told me that I was not to carry my pack so 'Blackie' is doing the job for me."

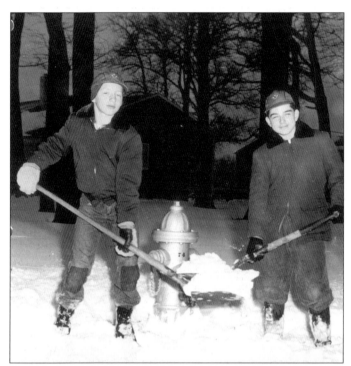

Richard Werner (left) and Larry Brogdon of Troop 15, Little Silver, participated in a countywide "good turn" project in January 1954 of removing snow from fire hydrants. The Cub Scouts had their own project, which was providing feed for birds.

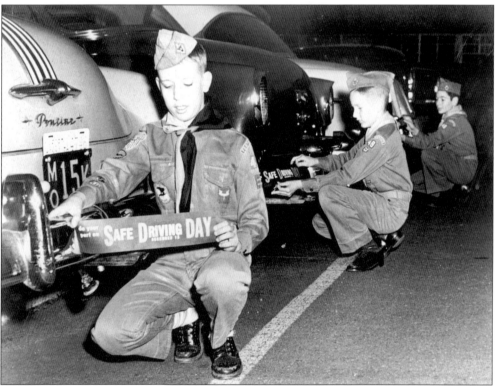

The Scouts of Troop 49, Fort Monmouth, apply bumper stickers reminding all motorists of Safe Driving Day.

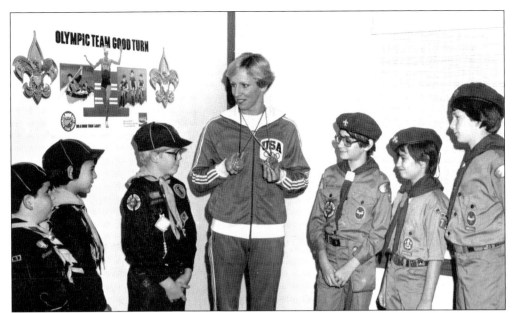

Olympic medalist Wendy Boglioli was named honorary chairman of the 1980 Olympic Good Turn for Monmouth Council. She won a gold medal in the 4 x 100-meter freestyle relay and a bronze in the 100-meter butterfly at the 1976 Olympics. The Olympic Good Turn was a nationwide Boy Scouts of America program to increase youth interest in Olympic sports and to raise funds for the U.S. Olympic team. Monmouth Council sponsored a Scout pentathlon at Thompson Park.

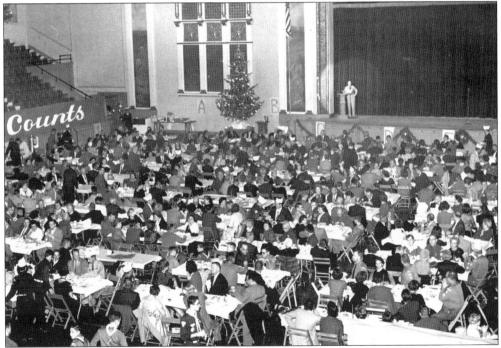

It appears that there was a big turnout at this council dinner in the Asbury Park Convention Hall in the 1960s.

Troop 50, Shrewsbury, is pictured in the 1960s.

Scout Executive J. Fred Billett salutes Fred Sietz of Troop 110, Lincroft, as Scoutmaster Andrew Lennert looks on. Lennert is a fixture in the Scouting scene in Monmouth Council with 46 years of tenure as Scoutmaster in 2003. Troop 110 has a strong advancement program that boasts 158 Eagle Scouts at last count. Other Scouts in the picture include Paul Engeldrum (in tee-shirt), Neil Krause (fourth boy from right), Jay Scruton (third boy from right), and Dr. Michael Mahoney (far right).

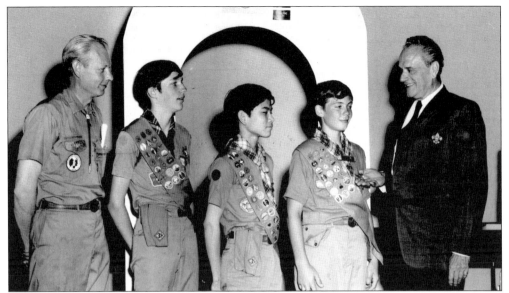

Joseph A. Brunton Jr. (right), the retired chief Scout executive, was an honored guest at the Troop 66, Matawan, Eagle Scout court of honor. Brunton, a resident of Matawan, was himself an Eagle Scout. The other participants pictured are, from left to right, Scoutmaster Greg Asbjorn, Mark Hassler, Quac Grace, and Bruce Asbjorn.

Winter campers at Forestburg must be well prepared. In the days before down-filled nylon jackets, wool was the clothing material of choice for most campers. The man on the right opted for a stylish, and hopefully warm, fur coat. One boy has both a sheath knife and a hatchet on his belt.

Winter camping always requires appropriate equipment. In the days before foam pads, a common material used to insulate and cushion a ground bed was alfalfa hay. Its insulating feature was most critical when camping during the winter. Putting the hay into a cloth bag, called a "tick," that served as a mattress are, from left to right, Vince Maslyn (field Scout executive), Cecil Lear (Scoutmaster, Troop 40), Lyle Antonidies, and unidentified.

Pictured is another winter camp scene, at Forestburg's Tecumseh Rock campfire ring. The site of many a noisy, fun-filled campfire during the summer months, it is very quiet in the winter. Judging from the placement of the benches, those first campfires were performed "in the round."

The telecommunications industry has played a significant part in the development of Monmouth County in the 20th century. High-tech laboratories at Camp Evans, Fort Monmouth, AT&T Bell Labs, Bellcore, and many other companies brought good jobs and bright people from all over the globe to Monmouth County. The Telstar I satellite, shown here, was launched in 1962 and provided the first "live" transatlantic television transmissions. Troop 57 called itself "the Telstar Troop."

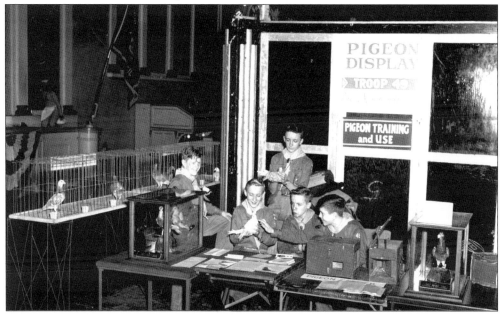

Troop 49, Fort Monmouth, demonstrates pigeon training at a 1950s Scout show. With the fort's long history of communications research, this was a natural choice. The homing pigeons were used to send messages from Camp Housman to Fort Monmouth.

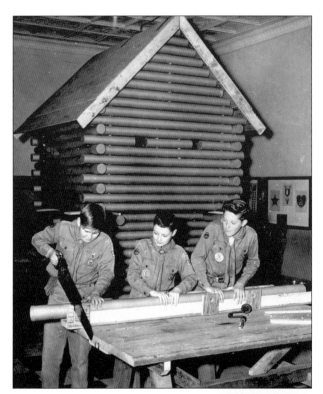

This life-size replica of the Forestburg stockade was built by Troop 19, Fort Hancock. They used 150 cardboard rug tubes to simulate the logs. The Scouts are, from left to right, Carl Bergquist, Jerry Turner, and Earl Howarth. The stockade model was featured at the 1962 Scout show at the Asbury Park Convention Hall.

A color guard prepares for the opening of the Scouts in Action show in 1946, while Troop 59, Manasquan, checks the lashings on their tower. The location is the Asbury Park Convention Hall.

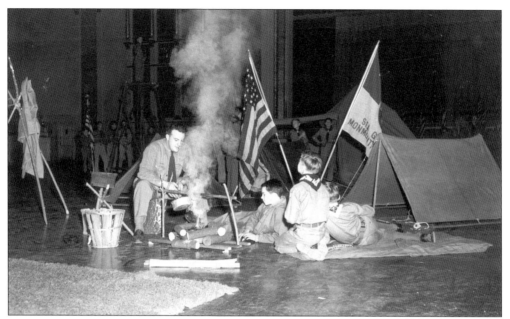

The Scouts of Troop 55, Sea Girt, set up a mock campsite inside the Asbury Park Convention Hall for one of the Scout shows *c.* 1950. One wonders how long that fire was allowed to burn before the fire chief told them to put it out.

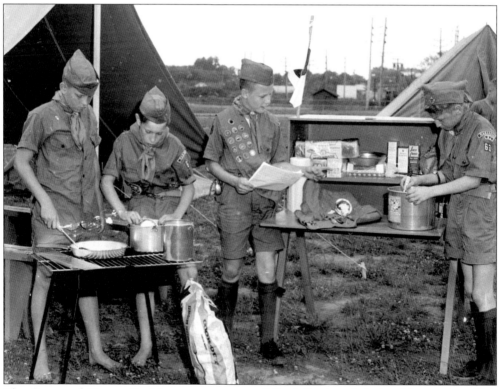

The Scouts of Troop 63, Manasquan, are carefully following their breakfast recipe. This photograph appears to have been taken at the council Scout show *c.* 1960.

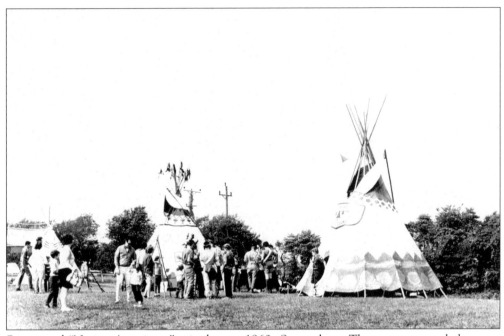

Scouts and "Native Americans" mingle at a 1960s Scout show. The center tepee belongs to Troop 70. The tepee on the right was that of Na Tsi Hi Lodge 71.

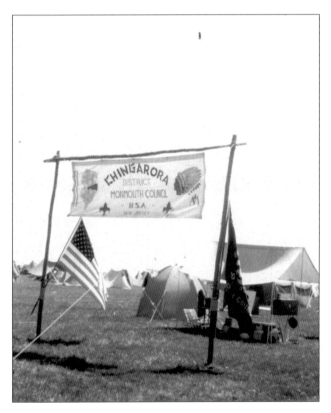

Chingarora District's gateway is pictured at a camporee in the 1970s. The district was named for the Chingarora Creek. The district was merged with Great Northern District in the 1980s to create the current Twin Lights District. (Photograph courtesy of Bill Burket.)

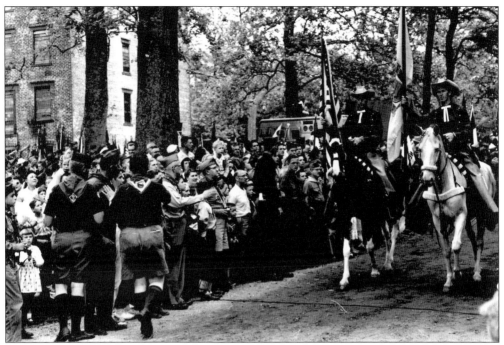

The council held a big camporee at Allaire in 1957 in conjunction with the dedication of the newly opened historic village by Gov. Robert B. Meyner. Attending the camporee were 1,500 Scouts. During the next several years, Scouts who volunteered as docents in the village earned an "Allaire Guide Service" neckerchief and certificate.

At the 1957 camporee at Allaire, the Scouts could purchase for 10¢ a facsimile of the $2 script issued by the Allaire Works. The bill could be spent in the store or could be saved as a souvenir.

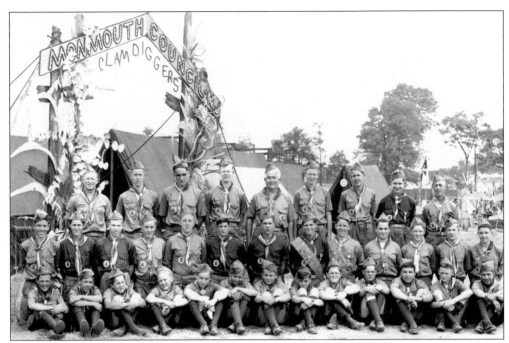

Four troops from Monmouth Council attended the 1950 National Jamboree, held at Valley Forge. Special gateways with hometown themes are a longstanding jamboree tradition. Belying its seaside location, the Monmouth contingent proclaimed themselves "the Clam Diggers." The Scouts slept in canvas-wall tents and cooked their meals on charcoal—not too different than camping today.

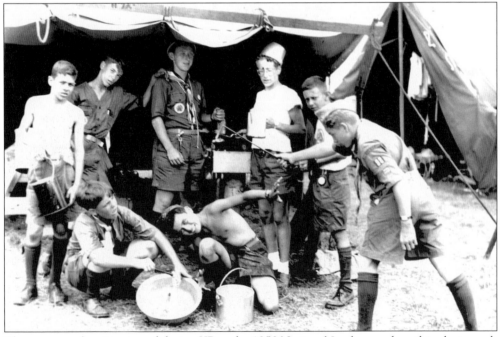

The guys were horsing around during KP at the 1950 National Jamboree when this photograph was taken. Apparently, cooking pots were good makeshift helmets.

This is one of the 1964 National Jamboree troops at Valley Forge, Pennsylvania. The troop leaders were Assistant Scoutmaster Arthur Lord (back row, far left), Scoutmaster Francis Bruce (back row, center), and Assistant Scoutmaster Tom Morley (back row, far right).

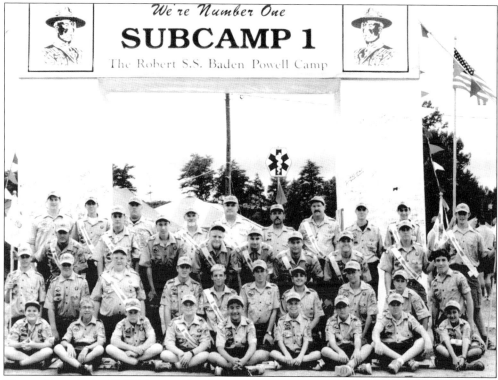

Pictured here is the 2001 National Jamboree contingent.

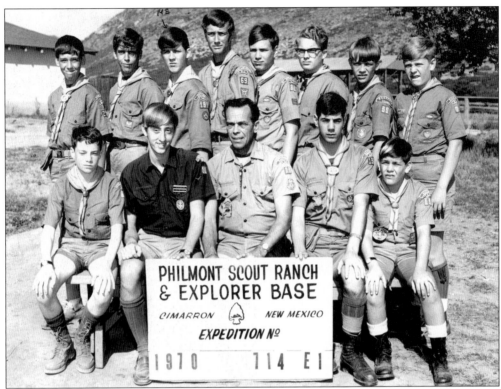

The "Screaming Yellow Zonker Stompers" crew poses before hitting the trail for 79 miles in 1970. The crew members are, from left to right, as follows: (front row) Danny Burns, Ranger David Hamilton, James Van Sant, Neil Curchin, and Patrick Gerbig; (back row) David Wilderspan, Gary Van Sant, Kevin Dorey, Scott Rogers, Robert Frances, Frank Waltz, Bob Ballou, and Dick Sodaman. (Photograph courtesy of Kevin Dorey.)

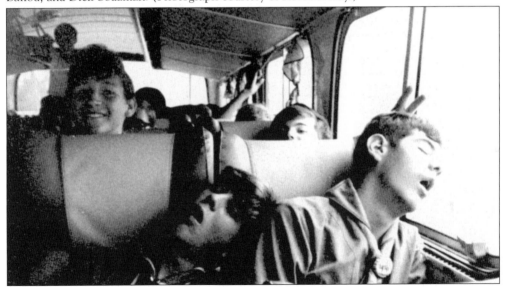

The trip to New Mexico could be monotonous, whether it was by rail, bus, or airplane, but it gave the guys a chance to rest up for the trail. (Photograph courtesy of Barry Cruikshank.)

On the trail at Philmont in 1970, the standard-issue Boy Scouts of America canvas backpacks were quite common. Judging by the critiques of Philmont hikers today, the backpacks have improved more than the food. (Photograph courtesy of Barry Cruikshank.)

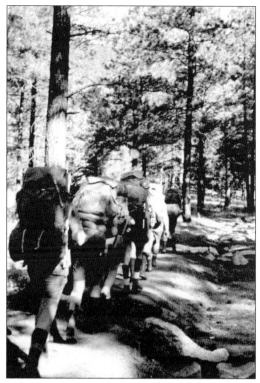

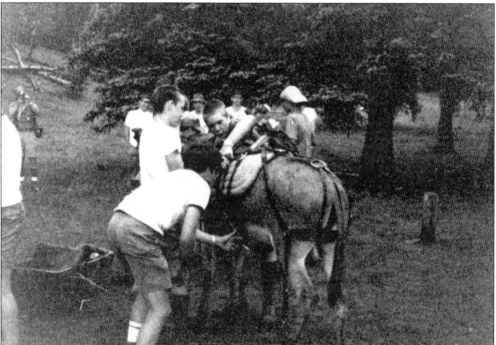

Packing the burros at Philmont was an adventure in itself. The ranch's trail hands would instruct the Scouts on the fine points of packing and leading the burros. They soon learned that you cannot lead a burro anywhere it does not want to go. (Photograph courtesy of Barry Cruikshank.)

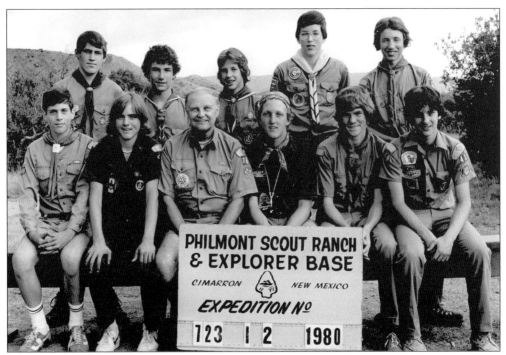

One of the Philmont crews is ready to hit the trail in New Mexico in 1980. The crew members are, from left to right, as follows: (front row) Cornelius Sheridan, David Crowninshield, William Schroeder, Pete Hedlin, Chris Colflesh, and Mark Ventura; (back row) Steve Davis, Alan Litts, Carl Gardner, Warren Michelson, and Eric Guevin.

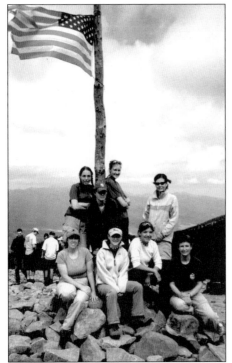

The council's first female Philmont Venture crew hiked the ranch in June 2002. In this photograph, they are celebrating the ascent of Mount Phillips. From left to right are the following: (sitting) Jodi Stark, Alex Scholtz, Kim Ward, and Peggy Crow; (standing) Sarah Bonn, Becky Scholl, Stephanie Crow, and Carrie Jacobson. (Photograph courtesy of Jodi Stark.)

Six

NA TSI HI LODGE

The "Wimachtendienk W.W." was created in 1915, but the first evidence of the Order of the Arrow in the Monmouth County area is the charter issued on October 5, 1933. The lodge name was Ohowa, and its totem was an "owl." Most of the activities of Ohowa Lodge 71 probably involved Camp Burton-at-Allaire. The lodge sent a contingent to the 1936 National Meeting at Treasure Island Scout Camp on the Delaware River, where five members sealed their bonds in Brotherhood. The lodge received a trophy for its participation in the 50th-anniversary parade in Manasquan. In its seven years of existence, Ohowa Lodge 71 inducted 113 members. It became inactive by c. 1940.

Through the 1940s, both Monmouth Council and Ocean County Council unsuccessfully attempted to reactivate Lodge 71. Monmouth Council's troops attended other councils' summer camps because it did not have its own summer camp. At those camps, the Scouts saw other Order of the Arrow lodges in action, and eventually a spark of interest was ignited.

A small group of youth Arrowmen and adults gathered in December 1949 in the cabin at Camp Housman on the old Allaire property just one mile from where the original Lodge 71 was founded. They formed a new lodge called Na Tasi Hi (meaning "in the pines") because Camp Housman was located on the northern fringe of the Pine Barrens. They chose "three pine trees" as the totem to represent the three parts of the Scout Oath and the three principles of the Order of the Arrow. Robert Schwab was chosen to be the first chief. Among the adults present at the founding was J. Townley Carr of Long Branch, who served as the lodge adviser until 1957. The new lodge was authorized to use the old number 71 and was chartered on January 1, 1950.

The ceremonial team of Cowaw Lodge 9 performed the first Ordeal ceremony. Seventeen Ordeal members were inducted into Na Tasi Hi in the autumn of 1950. This small group made their own costumes and thereafter held their own ceremonies, inducting more Arrowmen into the lodge each year. General membership meetings were held monthly, except during the summer.

The spelling of the lodge's name was corrected to Na Tsi Hi in 1951. By 1955, the membership exceeded 100 and was growing rapidly. With the acquisition of Forestburg in 1956, the lodge became very active and hosted the 1958 Area 2C Conference at Forestburg.

Through the more than 50 years of the lodge's existence, it has unfailingly served the council through large donations to the camps, providing service corps at camporees, maintaining the camps, promoting Scout camping, operating the Battle of Monmouth Trail, and training generations of young men to be the leaders of tomorrow.

Candidates take a break from work during one of the lodge's early Ordeals at Camp Housman c. 1956. Leaning against a tree on the right is a two-man saw used to cut the timbers for the new ceremonial ring seen below. Around the neck of each candidate is a wooden arrow that he carved for himself to signify being a candidate for the Ordeal.

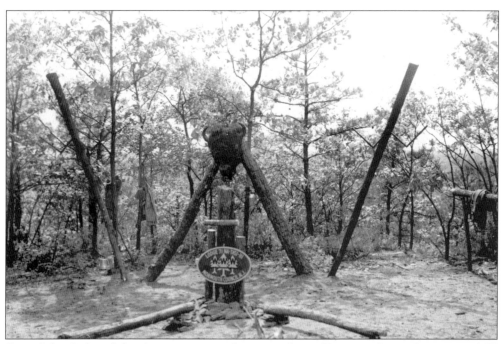

One of the Order of the Arrow ceremonial rings at Camp Housman featured an unusual W backdrop. The oval sign on the altar has the original spelling of the lodge's name (Na Tasi Hi); this sign still exists. Also note the bison head at the apex of the W. John Bruns remembers this site being built near the Allaire Airport because the first site was deemed to be too close to camp.

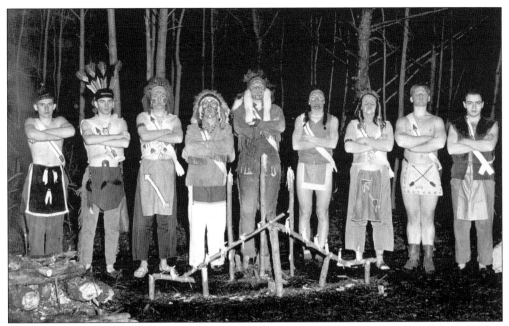

The ceremonial team in the early or mid-1950s was already well dressed and confident. Robert Schwab, the first chief, is in the center. On the far right are Frank Joyce (without shirt) and Mark Marcellia. The location, although not identified on this photograph, was almost certainly Camp Housman since that was the council's only camp before 1956.

The first Father-Son Banquet was held in the Pine Hollow Cabin at Camp Housman in 1951. Since it was just the lodge's second year of existence, the turnout must have been close to 100 percent. The first two Scouts in the left foreground are Richard Rose and John Bruns, both in Troop 43, Ocean Township. The pine tree patch on Rose's shirt is from Raritan Council's Camp Cowaw, which many troops used as their summer camp prior to the acquisition of Forestburg.

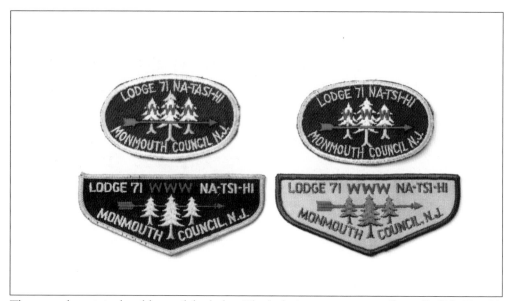

These are the original emblems of the lodge. The lodge's name was initially spelled Na Tasi Hi (top left), which was corrected to Na Tsi Hi (top right) in 1951. The oval patches were worn on the right shirt pocket. The first flap patch (bottom left) appeared in 1956, as this shape and location became the national standard for lodge insignia. The pine tree and background colors were reversed in the late 1950s, when members complained about the "sickly" yellow pine trees.

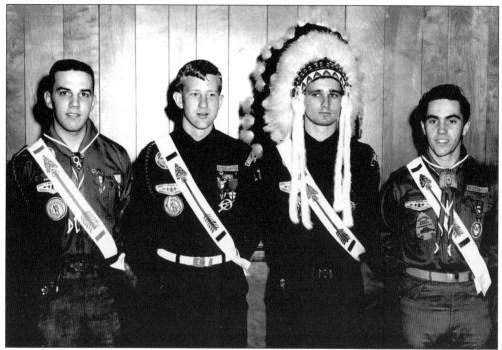

These 1963 lodge officers are, from left to right, Stanley West (secretary), Charles A. Spitz (vice chief), Victor Lorch (chief), and Edward McCormack (treasurer).

The National Committee recommended that each lodge promote camping by publishing the *Where to Go Camping* booklet highlighting the campsites and trails in or near their council. Na Tsi Hi published its first booklet in 1961. The editor was Bill Morgan, with advisers Sandy Tallman and Malcolm Freedman. In this edition, the council camps featured were Camp Housman, Hidden Hollow at Holmdel, Forestburg, and Skelbo Lodge Explorer Base.

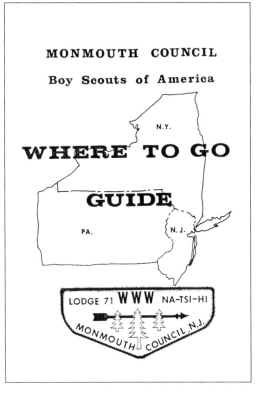

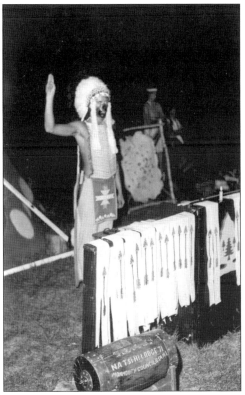

The Native American character in this ceremony c. 1970 is wearing face paint, which is now prohibited by the national regulations. In the foreground can be seen the Brotherhood log. It was carved by Tom Morley in 1957 and contains a list of the earliest Brotherhood members of the lodge.

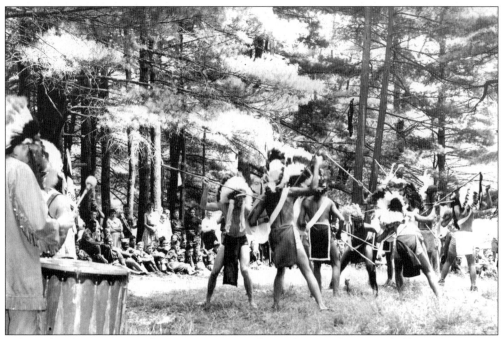

Judging by the women and young Scouts in the audience, this is probably a dance team exhibition on "parents day" during summer camp in the 1960s. The Order of the Arrow was very active at Forestburg, and it was a high honor to be tapped out for the Ordeal while at camp.

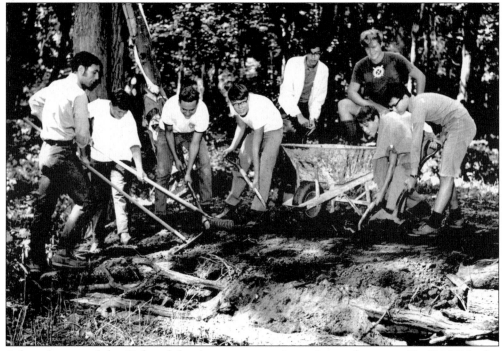

A key element of the Order of the Arrow program is service to the camp. Na Tsi Hi Lodge provided much of the manpower to transform the LeValley sisters' farm into Quail Hill Scout Reservation. This work group is hard at work building a trail at Quail Hill in the 1960s.

Another work project by the Order of the Arrow is under way. "Service to others" is part of the obligation of being an Order of the Arrow member.

The Order of the Arrow Pavilion adjacent to Scout Lodge was donated by the lodge and dedicated in the spring of 1980. During the fund-raising phase, it was described as a "pole barn," prompting a call to Thomas Fraley from an irate parent who wanted to know why thousands of dollars were going to be spent on a building to store poles.

The commissary committee operated a field kitchen at Quail Hill's picnic area to feed the lodge members and candidates during the Fall Powwows before Lawrence Lodge was built, because the only other kitchen at camp was a tiny one in the campmaster's office. Here we see the candidates being served a hearty lunch.

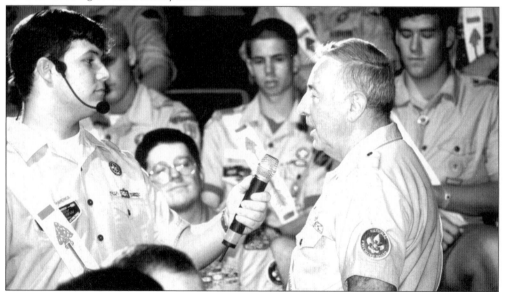

Dr. Carl Marchetti (right) of Ocean Township was the lodge adviser from 1967 to 1973. As a youth, he was active at the lodge, area, and national levels of the Order of the Arrow and became a friend of founder E. Urner Goodman. Marchetti has been a member of the National Committee since 1962, serving as national chairman from 1984 to 1993, and is the recipient of many Boy Scouts of America awards, including the Silver Buffalo and the Distinguished Service Award. He is seen here telling an anecdote about Goodman during the Heritage Show at the 2000 National Order of the Arrow Conference. (Photograph courtesy of Carl Marchetti.)

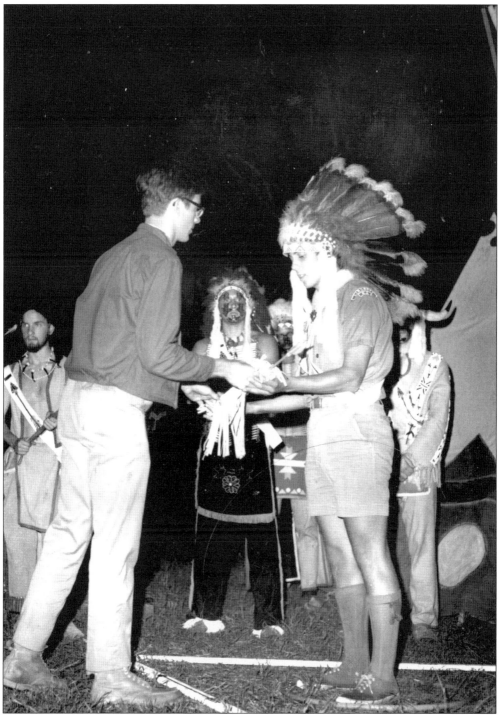

A representative of the Vigil Honor presented the ceremonial scroll and quiver to Chief Bill Burrows (right) at an early performance of the Gam'wing ceremony at Quail Hill in 1970. This ceremony formally invests the new chief for the coming year. The script was written by Robert Mayberry in 1968; he also made the scroll and quiver.

A special Ordeal was held for several council officials on November 27, 1968, at Quail Hill. The new Ordeal members are, from left to right, William Mattison, E. Donald Sterner, Irving J. Feist, Gen. Preston Corderman, Robert Stanley Jr., and Ed Ambler. Feist was the national president of the Boy Scouts of America from 1968 to 1971 and was the first to be a member of the Order of the Arrow.

The opening day for the Battle of Monmouth Historic Trail was January 4, 1975. The trail was designed and built by the lodge, with help from Troop 136. The trail is still in operation and continues to educate Scouts about the pivotal Battle of Monmouth in the Revolutionary War. In the front row are, from left to right, Roy Bradbury, Lodge Adviser Ed Weickel, Staff Adviser Tom Dunlap, Steve Merlin, Chief Tom Burnett, Don Brockel, Trail Chairman Ken Maloon, Trail Adviser William Burket, and Bud Hassler. (Photograph courtesy of Bill Burket.)

First Northeast Region Chief Peter Grimm of Rumson (left) and National Chief Brad Haddock (center) are welcomed by Chief Ken Maloon (right) to the Father-Son Banquet in 1975. Today, Haddock is the Order of the Arrow national chairman.

The lodge contingent poses at the 1977 Conclave at Yards Creek. The Arrowmen of the lodges in the area gather once a year, usually in June, to share the latest Order of the Arrow information, enjoy fellowship, and compete in Native American dancing and ceremonials. Sandy Tallman, the first lodge historian and a member since 1951, is second from the right in the middle row.

Robert Mayberry ("Tindeuchin") of Long Branch and Dennis "Eagle" Wood of Ocean Grove march in the parade in Ocean Grove in their Native American clothing. Mayberry and Wood were cornerstones of the lodge's fine dance team for many years. The team has won several section competitions, and individual dancers have competed at the National Order of the Arrow Conference. (Photograph courtesy of Mrs. Janice Mayberry.)

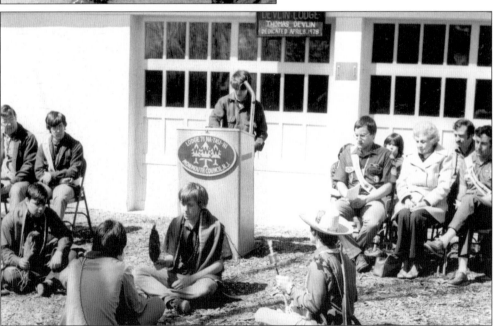

Chairman Tom Kosinski narrated from the podium while the dance team performed the gourd dance on April 8, 1978, at the dedication of Devlin Lodge, which was refurbished by the Arrowmen of Na Tsi Hi. The restored building was dedicated in memory of lodge member Thomas Devlin. Watching the ceremony are, from left to right, Lodge Adviser Ed Weickel, Lee Homyock, Chief Todd Pascarelli, and the Devlin family.

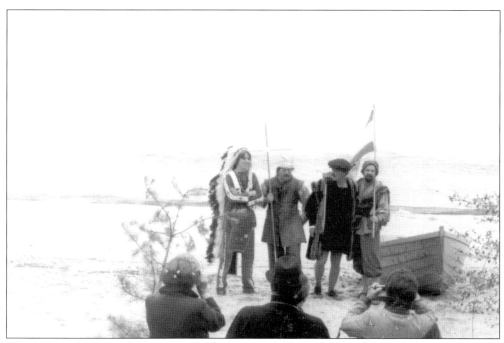

Chief Glenn Meloro of Troop 141, Belford, greeted "Columbus" and his sailors on the Asbury Park beach for the annual Columbus Day landing. The lodge has supported the city of Asbury Park in celebrating this tradition since the early 1960s.

Scott Busz of Troop 141, Belford, served as chief for two terms and went on to be chief of Section NE-4B. Scouting runs in the family—Scott's brother Ken was a district executive and Forestburg Scout Reservation director.

Calvin DeWitt of Troop 49, Fort Monmouth, performed at the annual Family Banquet at Buck Smith's in 1980. DeWitt was dance team chairman and an excellent dancer.

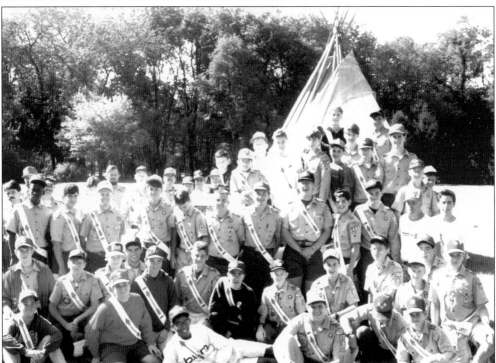

The brothers pose for a group shot at the Fall Powwow at Quail Hill in 1992 with the lodge tepee in the background. A new camp truck was donated and used for the first time at that powwow.

Seven

CUBBING AND EXPLORING

Once the Boy Scout program was well established for 12-year-old (and, later, 11-year-old) boys, the Boy Scouts of America began to consider a program for younger boys. In 1930, an "experimental" Cub program was launched, which was soon adopted as an official element of the Boy Scouts of America. At first controversial, since some felt that it would siphon adult leaders from the Boy Scout program, Cubbing quickly proved its merit and has become an integral part of Scouting. The first official Cub pack was organized in Long Branch in February 1931.

While the Cub Scout program has remained a stable mainstay of Scouting for 70 years, the "older boy," or "Senior Scout," programs have been overhauled several times. The Boy Scouts of America has tried several formulas with varying success. The following is a summary of the major Senior Scout programs (except Order of the Arrow, which was covered in chapter 6).

Sea Scouts, 1912–1948
Sea Explorers, 1949–1998
Sea Scouting, 1998–present
Rover Scouts, 1935–1952
Senior Scouts, 1935–1949
Explorer Scouts, 1935–1946
Explorer Scouts–Ranger Award Program, 1944–1951
Explorer Scouts–Silver Award Program, 1950–1965
Air Scouts, 1942–1948
Air Explorers, 1949–1965
Special Interest Explorers, 1958–present (transitioned to Learning for Life division in 1998)
Varsity Scouts, 1984–present
Venture Scouts (as a patrol in a troop), 1989–present
Venturing, 1998–present

The first Senior Scout unit in Monmouth Council was Sea Scout Ship 1, chartered in Red Bank in April 1929. The council has had as many as 11 active Sea Scout or Sea Explorer ships simultaneously, although in the last decade, interest has waned. The Explorer Scout program was quite active between the 1940s and 1960s, but membership in it has sagged since the 1970s. The new Venturing program (including Sea Scouting) has recently rekindled interest in the older boy (and girl) program.

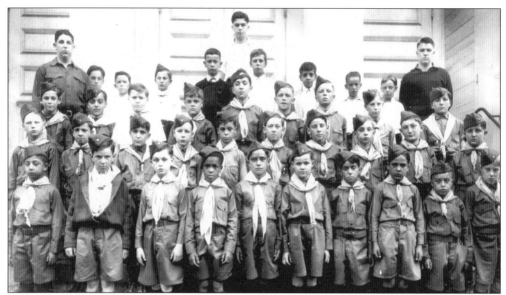

Before the Boy Scouts of America introduced the Cub program as an experiment in 1930, unofficial Wolf Cub packs following the British Wolf Cub handbook were already in operation across the country, such as this one from *c.* 1928–1929. The pins on their hats were imported from England. In 1933, the Cub program became an official part of Scouting.

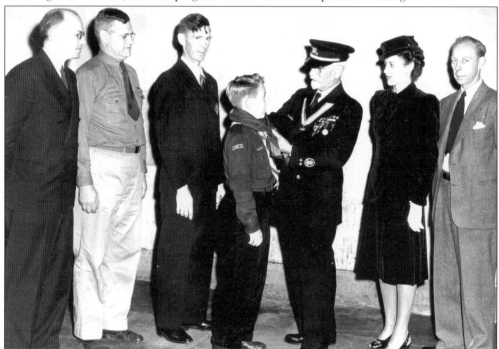

Dr. Edwin Stewart of Fair Haven inducts Cub Scout Joseph Fronapfel III of Belmar as a new Tenderfoot Scout at the *Scouts in Action* show at the Asbury Park Convention Hall in 1946. The show was the first indoor postwar project of Monmouth Council. Fronapfel later earned both the Eagle Scout rank and the Silver Award and was among the first inductees of Na Tsi Hi Lodge. His parents, Katherine and Joe Fronapfel, watch on the right.

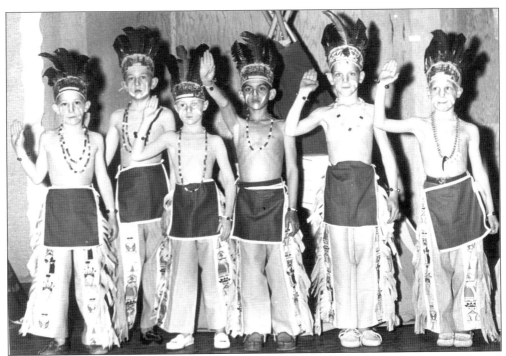

The Scout shows provided a chance for each Cub den and pack to choose a topic to study and prepare a skit or presentation. Whether they chose to portray Native Americans (above, pack unidentified) or frontiersman Davy Crockett (below, Pack 57), Cub Scouting got the boys personally involved in history through a learning-by-doing activity. You can just imagine the hours of sewing by the den mothers in preparing these costumes.

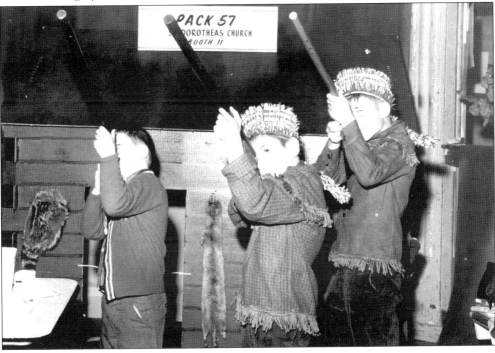

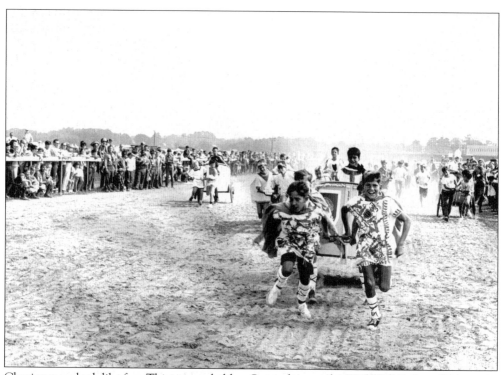

Chariot races look like fun. This was probably a Scout show at the Wolf Hill Park in Oceanport.

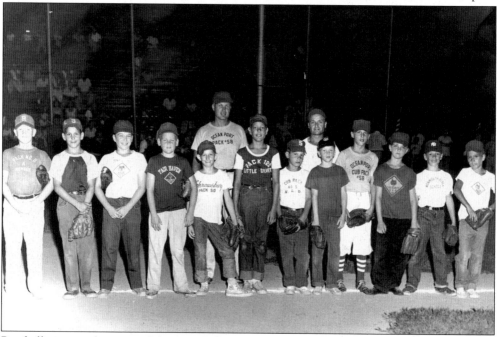

Baseball was another part of the "good clean fun" promised by Cub Scouting. Judging by the towns represented on these Scouts' shirts, this must have been the all-star team of Great Northern District. Scout Executive J. Fred Billett allowed Cub Scouts to form baseball teams before it was authorized by the national office.

Pack 73 looks sharp as they march past the Matawan Borough Hall in this parade. This type of activity exposes the boys to concepts like patriotism, community pride, and teamwork.

Two Cub Scouts of Pack 41, Ocean Grove, work on an arts-and-crafts project with their den mother at one of the Scout shows.

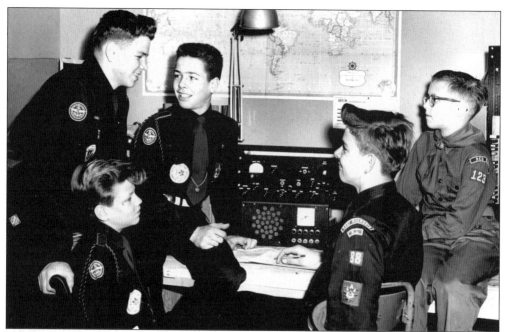

Explorer Scouts get together to listen to a ham radio broadcast c. 1957.

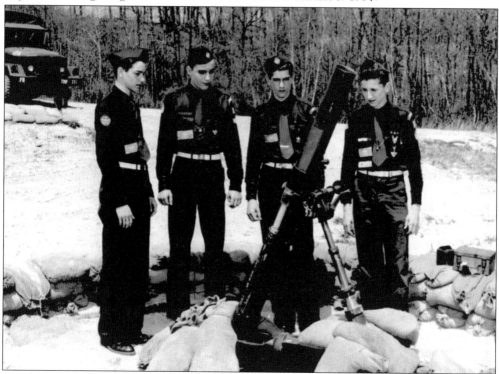

During an encampment in 1955 are, from left to right, Long Branch Explorers George Pitcher, Mickey Garreau, Paul Pitcher, and Ralph Goldstein. They are inspecting a heavy mortar at the infantry training center at Fort Dix and McGuire Air Force Base. An estimated 400 youths took part. (U.S. Army photograph.)

Explorers enjoy a formal dance with their girls in the late 1950s. One appealing difference between the Exploring program and the traditional Boy Scout program was the opportunity for coeducational activities. Check out those spiffy uniforms with the spats.

With a less formal atmosphere than the previous picture, this is the "Hillbilly Picnic" at McGuire's Grove in September 1954.

An Explorer band plays in the Asbury Park Convention Hall while the Order of the Arrow dance team looks on from the wings.

Members of the Joshua Huddy Fife and Drum Corps, Post 90, Colts Neck, lead a flag procession at the Scout show in 1982. Walter Voorhees was the post adviser. In 1988, the post traveled to France for the Rochambeau '88 celebration of France's participation in the American Revolution.

THE UNITED STATES NAVY

PRESENTS THIS
CERTIFICATE
TO

FRANK X. FLYNN

IN RECOGNITION AND ACKNOWLEDGMENT OF HIS PARTICIPATION

ON 22 AND 23 MARCH, 1952, IN THE

SECOND ANNUAL

U.S. NAVY
S___ ___ ___ EXPLORER ENCAMPMENT

U.S. NAVAL A___ ___, N.J.

COMMANDING OFFICER ENCAMPMENT DIRECTOR

SCOUT LIAISON OFFICER HOST COUNCIL EXECUTIVE

This certificate was presented to Frank X. Flynn of Union Beach for his participation in the 1952 Sea and Air Explorer Encampment at Naval Air Station Lakehurst. The encampments were frequently hosted at military bases. The military's "top brass" viewed supporting the Boy Scouts of America's Explorer program as good public relations as well as a potential recruiting opportunity.

Sea Explorers form-up for evening retreat at the third annual encampment at Naval Air Station Lakehurst in 1953. Lakehurst is known around the world as the site of the *Hindenburg* tragedy, but its more important role is in naval training. (U.S. Navy photograph.)

111

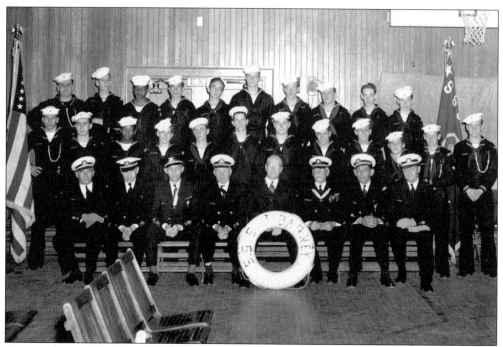

The members of Sea Scout Ship Joshua Barney (Ship 6), Atlantic Highlands, pose with council Sea Scout officials on the occasion of the presentation of the ship's flag in 1948 at the Atlantic Highlands Lions Club. This award qualified the ship for the Regional Flotilla.

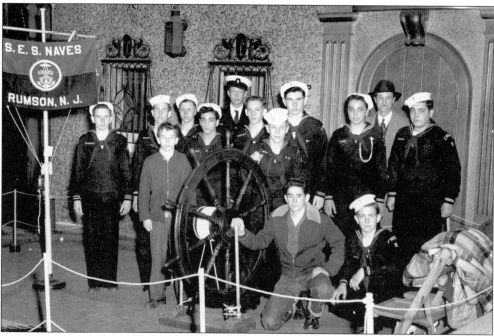

The members of Sea Explorer Ship Naves (Ship 11), Rumson, pose for a photograph c. the 1950s. Other records indicate the ship may have also gone by the name Navis.

Pictured from left to right, Stanley Buff (field Scout executive), J. Fred Billett (Scout executive), and Dr. Edwin Stewart (Sea Explorer committee member) prepare for the arrival of Explorers at the Explorer Base at Spermaceti Cove on Sandy Hook for an encampment in 1953. Stewart, of Fair Haven, was reportedly the oldest living Eagle Scout in the United States at that time.

The Explorers and Boy Scouts did a "good turn" at the Pet Show and Carnival held in 1955 at the Grape Farm, Lincroft, to raise funds for the Monmouth County Organization for Social Service (MCOSS, now called the Visiting Nurse Association of Central Jersey) by directing traffic and helping the ladies of the carnival committee. Sea Explorer Ronald Bowles (left) of Atlantic Highlands gets pointers on directing traffic from Trooper Edward Wilke (center) of the Shrewsbury Barracks while Edward G. Walder of Atlantic Highlands looks on.

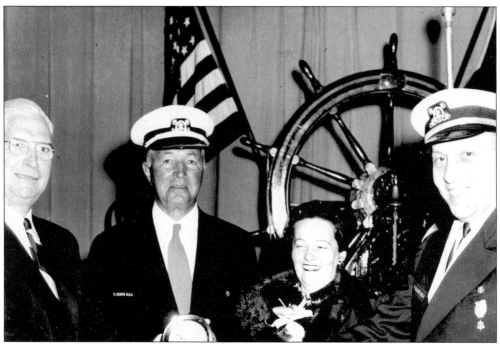

The council's Sea Explorer officials attend a Bridge of Honor ceremony. They are, from left to right, E. Donald Sterner, Commodore Amory Haskell of Middletown, an unidentified woman, and Sea Scout commissioner Louis Cooke of Rumson. Cooke's yacht was called *Scout*.

A Little Silver Air Explorer discusses a model airplane with a member of the U.S. Army Signal Corps during the encampment at Fort Monmouth in 1955. Rank advancement requirements in the Air Explorer program involved making or flying models that demonstrated airfoils, control surfaces, and other fundamental aviation concepts.

Air Explorers get a tour of a U.S. Army helicopter during the 1955 Fort Monmouth Explorer encampment. Maybe that amazingly large can of root beer attracted them.

In 1990, rescue squads were summoned to the Little Silver Borough Hall for a mock emergency. Eight Explorers from Post 175 were among the "injured" treated at the scene and transported to area hospitals. Participating in the drill at Monmouth Medical Center are, from left to right, Dr. Dolores McCarthy, RN Patty Gaughran, EMT Charles Hanish, RN Sue Tierney, and RN Louise Bosmans. The "victim" is Carrie Albrizio of Oceanport.

The Air Explorers were brought to attention for this group shot. Since several different squadron numbers are visible on their uniforms, this large group was probably a joint formation of all the Air Explorers at the encampment. The Air Scout–Air Explorer program never had the large membership of the traditional Boy Scout program, or even the Explorer Scout program. (U.S. Army Air Corps photograph.)

Eight

ADULT LEADERS

At the local council level, the Boy Scouts of America relies on both a paid staff and an extensive network of volunteers to accomplish the purposes of Scouting. Each has a particular role in the Scouting program. Many Scouters have appeared in the previous chapters, but to have a well-rounded history of Monmouth Council, it is important to acknowledge the contributions of the adult Scouters to the success of the Boy Scout movement.

At the front of the council is the Scout executive—the chief executive officer of the council. The Scout executive works with the (volunteer) executive board to set the overall direction for the council. He ensures that all Boy Scouts of America policies that are set at the national level are followed at the local level. The men who filled this position were Merritt L. Oxenham (1917–1923), John A. Danton (1924–1925), Edwin J. Bath (1926–1927), Frank C. Cobb (1927–1937), Ernest M. Blanchard (1937–1942), John Northup (1942–1951), J. Fred Billett (1951–1968), Orland L. Johnson (1968–1977), Charles D. Ball (1977–1983), Walter T. Weaver III (1983–1987), James W. Kay (1988–2001), and Matthew Thornton (2001–present). Matthew Thornton adds that the Scout executive also has the privilege of signing every Eagle Scout certificate.

The council has an executive board composed of dedicated men and women from across the council who are leaders in their respective towns and professions. Heading the board is the council president. The first president was W. Strother Jones of Red Bank.

The Boy Scouts of America offers a variety of awards to adult Scouters to recognize their service. The highest award that a council may bestow on a Scouter is the Silver Beaver. The first Silver Beaver presented by Monmouth Council was to Arthur Brisbane in 1932. He made available to the council the land and buildings at Allaire Village for Camp Burton-at-Allaire. There have been a total of 281 recipients of the Silver Beaver in Monmouth Council through 2002. There have also been seven Silver Fawns, an honor given to female Scouters in lieu of the Silver Beaver from 1971 to 1974.

To maintain a high-quality program, there are many training courses available for adults. The advanced adult training course is Wood Badge. This course traces its roots back to Gilwell Park in England in 1919. In the United States, it was initially offered only at the Schiff Scout Reservation in Mendham, the national training center for the Boy Scouts of America. To make it more widely available, councils and regions were eventually authorized to host Wood Badge courses. Monmouth Council has hosted seven courses: 347-1 (Forestburg, 1967), 347-2 (Forestburg, 1969), NE-IV-25 (Quail Hill, 1979), NE-IV-31 (Quail Hill, 1983), NE-III-105 (Quail Hill, 1989), NE-III-119 (Quail Hill, 1993), NE-II-79 (Quail Hill, 1996), and NE-II-108 (Quail Hill, 2001).

E. Murray Todd (left), George Bett (center), and J. Fred Billett survey the Metoque Mountain acquisition in 1965. Billett was Scout executive of Monmouth Council from 1951 to 1968. Forestburg, Quail Hill, and the Oakhurst Service Center were all purchased and developed during his tenure. Under his guidance, the council grew from 3,000 to 13,000 Scouts. After leaving Monmouth Council, he was regional executive for Region 1 (New England), regional director for the North-Central Region, and (as national director of operations) second in command of the Boy Scouts of America. He retired in 1979 with 42 years of professional service. In 2002, Central Camp at Forestburg was renamed J. Fred Billett Camp in his memory.

Tom "Chief Grey Fox" Morley of Oceanport was a ranger at Camp Housman and enjoyed Native American lore and creating dramatic campfires. He carved the totem poles on the front of the Forestburg dining hall and often carved neckerchief slides for his young Scout friends. In 1968, he was named the first life member of Na Tsi Hi Lodge and was a Silver Beaver recipient. Troops 140 and 240 in Middletown were known as the "Morley Rangers" and "Morley Scouts," respectively, in his honor.

Frederick Housman was council president from 1926 to 1929. He received the Silver Beaver award in 1939. The Housmans donated the property in Ocean County for the first Camp Burton. The camp on Hurley Pond Road at Allaire was named Camp Housman in Mr. Housman's honor; he left a large amount of money in his will to the council for camp improvements. The Forestburg dining hall is named Housman Memorial Lodge in his memory.

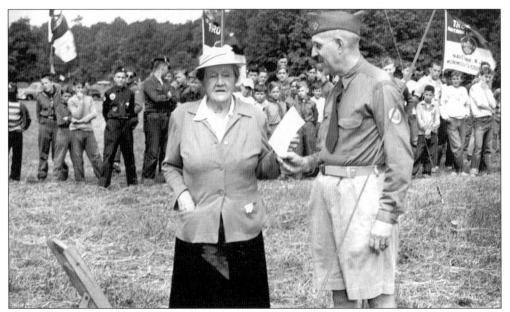

Geraldine Thompson presents a note or check to council commissioner William Mattison at the council camporee she hosted at her Brookdale Farm in Lincroft in 1954. Thompson was a prominent figure in Monmouth County and a lifelong advocate of Scouting. Her farm later became Brookdale Community College and Thompson Park. She was instrumental in Phoebe Brisbane's donation of Camp Brisbane (Camp Housman) to the council.

This *c.* 1960s photograph shows members of the Monmouth Council professional staff. They are, from left to right, Gene Richey, Sam Higbee, George Bett, J. Fred Billett, Bob Kreidler, Paul Bucklin, and John Bolte.

Prominent Scouters pose for a photo opportunity at the Boy Scout Air Show at Naval Air Station Lakehurst in 1949. They are, from left to right, Irving Feist, Gov. Alfred Driscoll, E. Donald Sterner, and Assistant Scout Executive Morgan Knapp. Feist, council vice president, held a variety of positions at the regional and national levels, including the national president of the Boy Scouts of America. Sterner was council president from 1941 to 1970. Knapp retired in 1951 as assistant Scout executive after 27 years of service to Monmouth Council. (U.S. Navy photograph.)

Forestburg camp officials prepare to raise the 1974 National Standard Camp pennant. They are, from left to right, Council Field Director Rheinhardt "Bud" Hassler, Camp Director Oliver "Woody" Forrest, and Dan Beard Camp Director Dennis "Eagle" Wood. Dennis Wood was a teacher by profession.

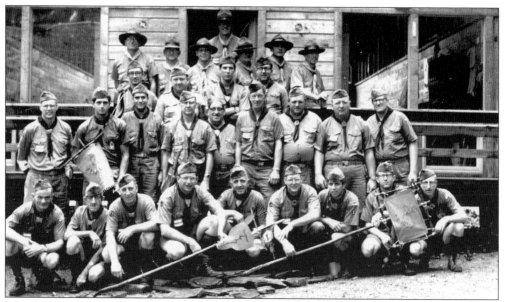

Wood Badge course 347-1 (above), held at Forestburg in 1967, was the first Wood Badge course hosted by Monmouth Council. Assistant Scout Executive George Bett was the course director. In 1969, Bett became assistant director of the Boy Scouts of America's Volunteer Training Service, where he was involved in implementing the Camp Schools and Wood Badge at Schiff and Philmont. Wood Badge course 347-2 (below) was held in 1969, also at Forestburg. The course director was Al Turner (front row, fourth from left). The syllabus for these courses was the same Scoutcraft skill-oriented one used at the famed Schiff Scout Reservation in Mendham.

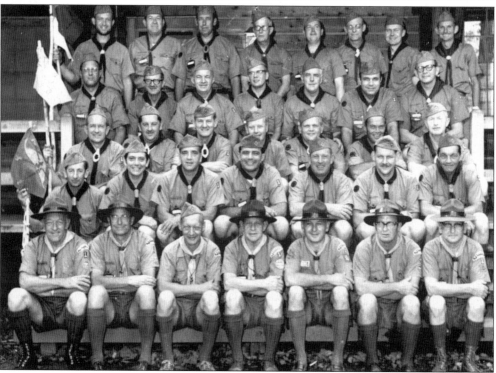

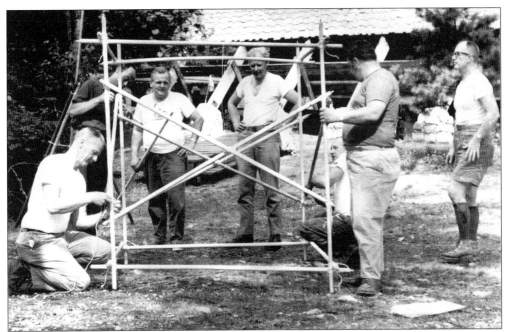

A large part of the original Wood Badge course was learning the traditional Scoutcraft skills, such as pioneering, nature and conservation, hiking and camping techniques, and outdoors cooking. In this picture, one of the patrols in course 347-2 built their lashing project on the parade field next to Todd Lodge.

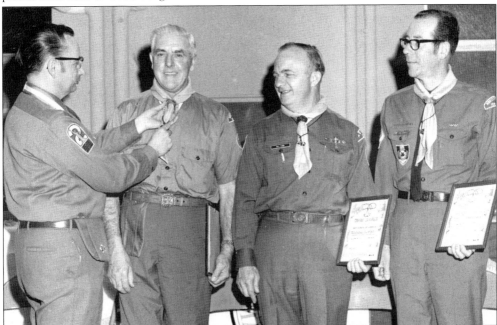

Andrew Lennert (left), Scoutmaster of Troop 110, Lincroft, presents the Wood Badge neckerchief, beads, woggle, and certificate to, from left to right, an unidentified man, Bill Ford, and Paul Bramhall. These are symbols of the completion of the final phase of Wood Badge training.

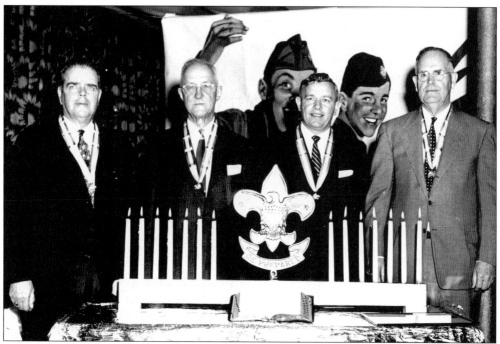

These members of the Silver Beaver class of 1958 are Albert R. Quackenbush (second from right), Amos T. Henderson (right), Lloyd S. Cassel, and Albert W. Van Nostrand.

The distinguished 1998 class of Silver Beavers are, from left to right, Sanford "Sandy" Brown, Albert "Wes" Olson, Tom Turner, Thom Ritchie, and Robert Smith Jr. Brown is a past chief of Na Tsi Hi Lodge. Olson is a lifelong Scouter and has camped at Forestburg every year since its opening. Turner was commissioner for Thunderbird District. Ritchie is council commissioner and a recipient of Monmouth Council's Distinguished Eagle Scout Award. Smith is a past council president.

Benedict "Gentle Ben" Mazzucco (shown here) and Gus Bogart (see chapter 4) were known as "Frick and Frack" around Dan Beard Camp. Both men served as Dan Beard directors. Mazzucco was a Massachusetts Institute of Technology graduate, and his wife, Mary, is a retired professor from New York University. The Mazzuccos are Hanoverian horse breeders, and they board horses on their 100-acre farm in Millstone. Whenever a Scout was homesick at Forestburg, Mazzucco would tell him stories about his favorite horse, Luke.

Thomas Devlin, in whose memory Devlin Lodge at Quail Hill is named, was an active Scouter and Order of the Arrow member. Devlin was the adviser of the Order of the Arrow's camp-promotion committee and assisted Lodge Adviser Carl Marchetti when the lodge's leadership was reorganized in the 1960s.

Gary Motsek (left) and John Cox pause for a picture during Great Northern District's patrol method training (PMT) at Quail Hill in 1969. John Cox, Scoutmaster of Troop 201, Rumson, developed the PMT syllabus and was course director for many years. PMT was the forerunner of the current patrol leader skills weekend. (Photograph courtesy of Barry Cruikshank.)

The 2002 Monmouth Council professional staff includes, from left to right, Jodi Stark, Magne Gundersen, Brian Strasavich, Matthew Thornton, Greg Rathje, and Brenda Adams-John.

Irving Feist (left), Joseph Brunton Jr., and Lady Olave Baden-Powell stroll through the 1967 World Jamboree in Idaho. Brunton was the chief Scout executive of the Boy Scouts of America from 1960 to 1967 and lived in Matawan. As the head of the host country for the jamboree, he also served as "jamboree camp chief." Feist was the Boy Scouts of America president from 1968 to 1971 and lived in Shrewsbury. (Photograph courtesy of the Boy Scouts of America.)

REFERENCES

Davis, Kenneth P. *The Brotherhood of Cheerful Service: A History of the Order of the Arrow*, third edition. Irving, Texas: Boy Scouts of America, 2000.

Kisenwether Jr., Rev. Lewis K. *Forestburg: Legends, History, Memories*. 2002.

National Cub Scout Committee. *History of Cub Scouting*. Irving, Texas: Boy Scouts of America, 1987.

Peterson, Robert W. *The Boy Scouts: An American Adventure*. New York: American Heritage, 1984.

Reis, Mitch. *A Guide to Dating and Identifying Boy Scouts of America Badges, Uniforms and Insignia*, third edition. 2000.

Sitkus, Hance M. *Images of America: Allaire*. Charleston, South Carolina: Arcadia Publishing, 2002.

Sterner, E. Donald, and J. Fred Billett. *Fifty Years of Growing Strong to Serve America: Monmouth Council BSA Annual Report*. Oakhurst, New Jersey: Monmouth Council Boy Scouts of America, 1960.